# LEARN

# CALLIGRAPHY

OTHER BOOKS BY MARGARET SHEPHERD

Learning Calligraphy
Using Calligraphy
Capitals for Calligraphy
Borders for Calligraphy

Calligraphy Made Easy
Calligraphy Projects
Calligraphy Alphabets Made Easy
Calligraphy Now
Reissued as A Manual of Modern Calligraphy

Basics of the New Calligraphy
Basics of Left-Handed Calligraphy
Modern Calligraphy Made Easy

Calligraphy for Celebrating your Wedding
Calligraphy for Celebrating your Newborn

The Very Small Calligraphy Calendar

The Alphabet Advent Calendar
The ABC Advent Calendar

# Learn Calligraphy

## THE COMPLETE BOOK OF LETTERING AND DESIGN

# Margaret Shepherd

BROADWAY BOOKS

NEW YORK

BROADWAY BOOKS
and its logo, a letter B bisected on the diagonal, are trademarks of Broadway Books, a division of Random House, Inc.

For information, address Broadway Books, a division of Random House, Inc., 1540 Broadway, New York, NY 10036.

Broadway Books titles may be purchased for business or professional use or for special sales. For information, please write to: Special Markets Department, Random House, Inc., 1540 Broadway, New York, NY 10036.

Visit our website at www.broadwaybooks.com

Library of Congress Cataloging-in-Publication Data

Shepherd, Margaret
    Learn calligraphy: the complete book of lettering and design /Margaret Shepherd.
       p. cm.

    1. Calligraphy—Technique. I. Title.

NK3620 .S48 2001
745.6'1—dc21                               00-053016

ISBN 0-7679-0732-9

Learn Calligraphy is an expanded version of the original classic, Learning Calligraphy (1977), completely rewritten with new text and reillustrated with new calligraphy and new drawings.

Learn Calligraphy has been carefully structured to help you learn and practice. To that end, you are welcome to photocopy the Guideline pages for your own use or print them out from the website at margaretshepherd.com, enlarging or reducing them to suit your pen. Please do not photocopy individual Alphabets and Guidelines to hand out in class, however, because students need to read the chapter's lessons that explain about the structure of the letter. By the same token, do not photocopy whole chapters to give out, either, because students need to see each alphabet in relation to the other alphabets and to the visual principles outlined in the beginning of the book. Any beginner will ultimately be better off owning the entire book than photocopying pages and chapters out of context.

20 19 18 17

# CONTENTS

Arch the pages to expose the tabs.

Locate each chapter easily using the thumb index.

## ACKNOWLEDGMENTS

I have been helped by many generous people in the process of writing this book. Those who tried out the practice exercises early on were particularly kind: students and faculty in Boston University School for the Arts workshop; members of the Connecticut Valley Calligraphers' guild; art teachers in the Framingham Schools in-service course; residents of Hale House; students in the City of Boston's Youth Fund Mural Crew; and a group of enthusiasts at the St. Botolph Club. I am grateful to Alston Purvis, Kathleen Borkowski, Leslie Miller, Jane Poltier, Heidi Schork, and Anita Lincoln for help in organizing these groups.

I want to thank my agent, Colleen Mohyde of Doe Coover, for helping bring this book to life. I am most grateful to my editor, Tricia Medved, who always seemed to have a clearer idea of what this book could become, and kept me at it until I saw it, too. It is a better book because of her.

I am extra grateful to my children—Jasper, Zack, Zoë, and Lily—who coped and cheered and pitched in, and to my husband, David Friend, who encouraged me all the way along.

The following material is used with the permission of its owners:

9 Detail from wall painting. Metropolitan Museum of Art, Egyptian Expedition, Rogers Fund, 1930. (30.4.44).

12 100 Ballads: Christine de Pisan writes. Ms. Fr. 835, fol. 1. (detail), Bibliotèque Nationale, Paris, France. Foto Marburg/Art Resource, NY.

12,23 Giovanni Stradano (1523-1605). The Printing of Books (details). 16th c. Bibliothèque Nationale, Paris, France. Giraudon/Art Resource, NY.

28 "Before the shot." (Sep. 3/15/58) by Norman Rockwell. Copyright © 1958 by the Norman Rockwell Family Trust.

28 Navy veteran Freddie Chase, Sr., at the Vietnam Memorial. Photograph from Agence France Presse.

44 Inscribed marble slab advertising the Baths of M. Crassus Frugi. Found in 1748, re-used as a shelf within a shrine just outside the Herculaneum. Museo Archeologico Nazionale, Naples, Italy. The Pierpont Morgan Library/Art Resource, NY.

44 Carved inscription from the tomb of a Legionary. Landschafts-verband Rheinland/Rheinisches Landsmuseum Bonn.

61 Page from the Book of Kells. The Board of Trinity College, Dublin.

60 Lyrics of "Happy Talk" by Richard Rodgers and Oscar Hammerstein II. Copyright © 1949 by Richard Rodgers and Oscar Hammerstein II. Copyright renewed. Williamson Music owner of publication and allied rights throughout the world. International copyright secured. All rights reserved. Reprinted by permission.

87 Alphabet. Addison 31845. The British Library.

93 Silvestro dei Gherarducci. Nativity, in initial P. Single leaf from a Gradual. Italy, Florence, Monastery of S. Maria degli Angeli, last third 14th c., 59.0 x 40.0 cm. M. 653, f. 1. The Pierpont Morgan Library, NY, USA. The Pierpont Morgan Library/Art Resource, NY.

Gherardo del Fora. Initial "H" with putti holding a shield. Italy (Florence) 1488. M. 496, f.92. The Pierpont Morgan Library /Art Resource, NY.

These individuals generously lent or made illustrations:

145, 155, 165    Robert Boyajian
45, 89    Barbara Karr for the estate of Edward Karr
167    Jean Wilson, Lisa Richards

Material throughout the book by Tom Costello, Michelle Hlubinka, Zoë Friend, and Margaret Fitzwilliam is used with their permission. SPECIAL THANKS to Margaret Gorenstein, Gerhardt Gruitrooy, Winifred Kelley, Tom Hansen, Cassie Reynolds, Peyton Richter, Jasper Friend, and Yehudi Wyner.

Dedicated to Norberto Chiesa, extraordinary teacher.

*"They have a wonderful author-editor relationship."*

AUTHOR'S FOREWORD

Learn Calligraphy is the book I wish I'd had when I first started out. I've put between its covers the lessons I've learned from many years of lettering. In it you will meet the basic alphabets I rely on, grouped in the categories that make sense to me. You will read about the materials I recommend and why, practice the exercises that I think will help you the most, and watch out for the mistakes that I learned to avoid.

Learn Calligraphy is also the book I wish I'd had when I first started to teach. It includes an overview of the main features of each alphabet, its historical importance, and a thorough grounding in the "why" to practice as well as the "how" to practice. The words you read are what I would say to you in person, the diagrams are what I would sketch on the board, the master alphabets are what I would letter for you to take home. This book will help you teach yourself, teach someone else, or teach a group.

Learn Calligraphy, however, is much more than a how-to book. I don't want you just to do what I do in calligraphy; I want you to see what I see, and love what I love. All the illustrations in this book, by me and by other calligraphers, have been chosen not only to instruct you but to inspire you. The art of calligraphy is about vision. After you read this book—with or without a pen in your hand—you will see the letters around you in new light.

Learn Calligraphy, in addition, is more than just what is shown on its pages. When you finish reading, it will help you choose a direction to explore next. I have provided online help at margaretshepherd.com that includes guidelines to print out, tips for teaching, sources for materials, answers to frequently asked questions, and suggested reading.

Learn Calligraphy, ultimately, is about more than calligraphy. It is about what can happen when people learn to write, and to read, in the very best way. As soon as you begin calligraphy, you can use it every day to satisfy your eyes and challenge your mind and elevate your spirit. I wrote this book to show you how. Enjoy.

M. Shepherd

February
second
2001

pen

### THE ALPHAPETS IN THE ALPHABETS

Each chapter in Learn Calligraphy introduces a creature who embodies some key aspect of the letter style. Although these particular animals are my own idea, they come from a worldwide, ages-old tradition of using natural objects as metaphors when words and diagrams are not enough. Chinese scribes

have always turned to the landscape of rock and water to describe the shape of their strokes; Arabic scribes rely on the underlying forms of seeds and swords; Renaissance designers in Italy used the human body as a measuring device to keep the letter structure in balance.

Each alphapet helps show not only how the letter looks but how it acts. Cats interpret the Roman alphabet's elegance and precision while emphasizing each letter's individuality and distaste for crowding. Celtic dragons have the body language of cats on a power trip—funky, sprawling, egotistical, emphatic. Gothic penguins look virtually identical in their black tuxedos and don't mind being crowded into rows, except for the occasional peacock-feathered capital. The mild personality of the gentle, unpretentious bunny embodies the familiar Book-hand alphabet we take for granted everywhere. And Italic is personified by a nicely dressed human who can accessorize her little black dress to go anywhere.

Most of the alphapets came from the pen of constant sketcher Zoë Friend, whose cats prompted me to look for other animals in other alphabets. Michelle Hlubinka created and drew the dragons, thought up the bunnies, and drew many early drafts. Tom Costello drew the twin Roman guys.

I hope this zoo of animals, and the creatures you think up for yourself, will add an extra dimension to your enjoyment. Once you start to see them, from the Gothic penguins in the masthead of the morning newspaper to the silk scarf in every Italic swash, the alphabet will always be full of life for you.

# SCRIBES & MATERIALS

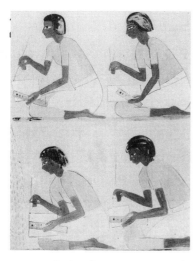

Ever since humans began speaking, they have supplemented their sounds with gestures. Writing is really an extension of gesturing— a way to make a motion visible, memorable, and lasting. For thousands of years people wrote with whatever was handy. They kicked furrows in the sand, they cut notches on sticks, they pressed dents into clay, they tied knots in string, they painted symbols on bark, they scratched names on metal, they scrawled messages on walls. The many different words we use for "calligraphy" reflect the many different ways to make a mark: script comes from words for "scrape" and "scratch"; the Greek -graphy ending appears in technical terms as well as "groove" and "engrave"; write shares roots with "render" and "work"; and text comes from the Latin sources for "texture" and "textile." Calligraphy with a pen is only one of the many ways people have thought up to make speech visible.

Our cultural ancestors the Romans, whose alphabet we still use today, were enthusiastic wall-writers. With a paintbrush or lump of charcoal, they wrote official announcements, advertisements, and political slogans, as well as gossip, insults, and jokes ("Everyone writes on walls but me" was among the perfectly preserved graffiti found under the ashes at Pompeii). They carved out the most important inscriptions to make them last, and painted the carved parts to make them readable.

With the decline of the Roman Empire, the conditions that had nurtured the Roman letter changed too. Gone were centralized authority with its official inscriptions, the network of commerce, the buildings of marble, the sunny Mediterranean cityscape. New alphabets and arts emerged all along the northern and western rim of the old empire as power dwindled at its center.

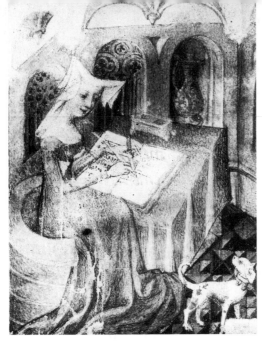

The Celtic scribes of the Dark Ages and the Gothic scribes of the Middle Ages worked indoors, in the colder, darker climate of northern Europe. With small pens made out of feather quills, they wrote small letters. Their main concern was to copy, glorify, and preserve the texts of the Christian religion. Working with a team of skilled illuminators, gilders, and miniaturists, the medieval scribes created richly decorated pages in styles that reflected the magnificent church architecture, textiles, and stained glass around them. The parchment pages were then bound between protective covers. For a thousand years writing was in the hands of specialists who raised the craft of calligraphy to the level of fine art, glorifying the word of their God.

During the Renaissance, Greek and Roman ideas were rediscovered, and with them the formal carved capitals of classical inscriptions and the pen capitals of early manuscripts. At the same time, the invention of moveable type and the adoption of papermaking technology from Central Asia helped the printing press to replace the scribe as the main way to produce books. The emerging new Italic and Bookhand were yanked away

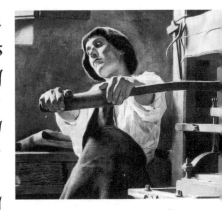

from their pen origins and transplanted into the geometric metal world of type. For three centuries, master typographers and their apprentices perfected the design, cutting, casting, and setting of mechanically perfect type fonts. The visual purity of the type-set page became the new standard reading format for an increasingly literate public.

As people read more, they wrote more, and as the delivery of mail got more reliable, they wrote to each other. They modeled their handwriting on the pointed-pen letters of copperplate engraving and etching, not the broad-pen letters of Italic type. The professional scribe's profession disappeared. The craft of calligraphy hit a low point during the Industrial Revolution, when manufactured books, textiles, and housewares drove handmade things out of fashion.

Calligraphy was revived again some 130 years ago during England's Arts and Crafts Movement, along with many medieval techniques for cutting pens, mixing ink, tanning parchment, and laying gold leaf. Calligraphy and the related book arts began to attract designers and visionaries who revitalized the typeset page by reconnecting it to the handwritten manuscript.

Steel nibs and flexible fountain pen ink reservoirs added convenience to early-20th century calligraphy as graphic designers spread the hand-lettered alphabet to posters, signcards, logos, and book covers.

Another wave of interest in calligraphy swept America in the 1970's as cartridge pens, markers, and copiers brought the mechanics of the craft down to the threshold of the hobbyist. Amateurs found themselves with access to standardized, reliable, inexpensive materials; to color reproductions of the world's most inspiring manuscripts; to the written, spoken, and filmed advice of experts in the field; and the leisure to enjoy them all. The calligraphic talents of this generation of artists then fueled the alphabet innovations of the digital typeface revolution.

Even though today's calligraphers can use a computer to make thick and thin penstrokes, create alphabet fonts, design layouts, send images, and print out documents, the best letters still originate in a real pen on real paper. Traditional forms, and the pleasure that comes from lettering them by hand, will continue to shape the future of writing for a long time to come.

In this book we will study the seven basic letter styles of the last 2000 years by getting to know the materials and people that formed them. History teaches you about the letters; the letters teach you about history. When you begin calligraphy, you join a distinguished group of scribes who have seen the world, and shaped it, with their pens.

# THE VOCABULARY OF THE PEN
*As you read this book, you will find some specific terms you will want to know.*

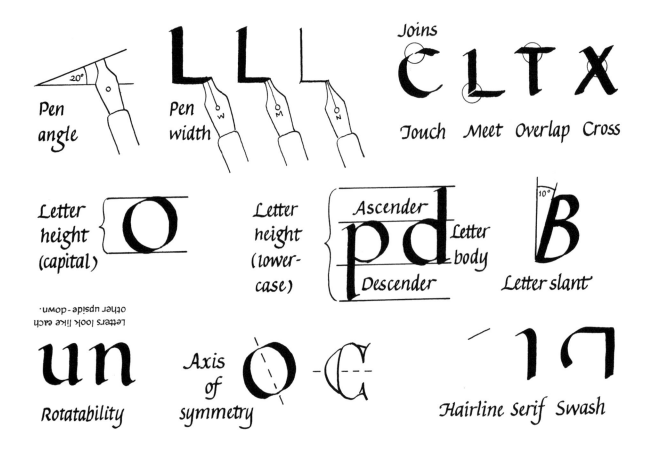

Pen angle

Pen width

Joins

Touch  Meet  Overlap  Cross

Letter height (capital)

Letter height (lower-case)

Ascender  Letter body  Descender

Letter slant

*Letters look like each other upside-down.*

Rotatability

Axis of symmetry

Hairline  Serif  Swash

EQUIVALENT TERMS
ALPHABET = HAND = STYLE = TYPEFACE = SCRIPT = FONT = CHARACTER SET

OTHER NAMES OF THE MAJOR ALPHABETS
ROMAN   Trajan, Quadrata, Rustica
CELTIC   Uncial, Half-Uncial, Irish, Insular
GOTHIC   Blackletter, Grotesque, Old English, Fraktur, Textura
GOTHIC CAPITALS Lombardic, Versal, Majuscule
BOOKHAND   Roman Lowercase, Carolingian Minuscule, Foundational
ITALIC   Current, Cursive, Chancery, Chancellaresca

# GETTING STARTED

The next 10 pages will help you choose your materials, find a starting point, arrange a writing area, sharpen your vocabulary, & begin to learn calligraphy. You should think about what you want to achieve, for both the short term and further ahead; then choose a chapter to start with. Remember that while this book can guide you through a year of formal study, if you are in a hurry you can turn directly to the specific alphabet that suits your project:

- Lay the foundation for understanding the visual principles of the alpabet: master the Roman alphabet, the purest style.
- Slam-dunk a project that has a tight deadline: the Celtic alphabet is quick to learn and easy to read.
- Make an award or a Christmas greeting: use Gothic letters and capitals.
- Introduce children to calligraphy: online or on a photocopy, let them paint color and gold on Gothic drawn capitals, or draw their own.
- Letter a quotation artistically: use Bookhand and any ornamental capital.
- Improve your handwriting: follow the Italic practice exercises every day for a month. Include a variety of handlettered projects in your daily routine.
- Design a logo, monogram, or letterhead: combine Gothic or Italic capitals.
- Express yourself artistically: play with abstract swashes and punctuation.
- Throw a party, in any style: if you design an invitation and address the envelopes, you will need numerals and punctuation to match.

After you have browsed through the whole book, in an armchair, you should sit up and work through one chapter, at a desk. Once you have begun to master even one letter style, and as the people around you see your new skill, you will find calligraphy projects—and the projects will find you!—for years to come.

CHOOSE A PEN        You can learn calligraphy with the handcrafted tools of yesterday, the standardized products of today, or the emerging technologies of tomorrow. The person behind the pen is more important than the pen itself. Be adventurous; try a variety of pens from all eras; trust your judgment of what feels comfortable and looks right; compare strokes with other scribes.

To make your own traditional pen from bamboo or feather, shape it as shown here, using a very sharp knife.

If you prefer to buy a pen, you can read about the advantages and disadvantages on the following page and choose a dip pen, fountain pen, or marker. These pens make the same basic stroke shape as the handmade pens.

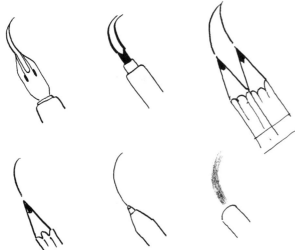

If you want the special split-pen stroke that appears on pages 112 and 145, choose a metal nib, cut a notch out of a marker, or tape two pencils or pens together.

You don't have to have a broad-edge pen at all to learn the structure of Roman, Italic, Bookhand, and swashes. Pencil, ballpoint, and chalk make monolines.

After you have familiarized yourself with the pens of yesterday and today, you should look around you for the pens of tomorrow. Spray cans, holograms, ink jet printers, pixels, and lasers will write some of the calligraphy of the future, guided by the hands and eyes—and hearts—of people like you. Whether you write with a peacock feather or a Popsicle™ stick, the most important thing is, in the words of Edward Johnston, "To make good letters and arrange them well."

## ADVANTAGES AND

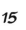

## DISADVANTAGES OF EACH PEN

### DIP PEN

#### THE ULTIMATE CHOICE

RANGE OF NIB WIDTHS
.5 mm    to    3 cm

+ The thin metal nib is responsive and precise. The opaque ink that only a dip pen can accommodate has the virtues of permanence, intensity, and a rainbow of color choice. Nibs from half a dozen manufacturers can range from one inch down to 0.5 mm. Nibs are inserted interchangeably on the pen shaft, and sharpened or replaced when dull.

− The nib is delicate. Pushed strokes can snag a small nib on the paper surface and dry up a large nib's ink flow. It must be rinsed after every use. It is available at only a few specialized art stores and mail-order sources. The open ink bottle can spill. Dipping the pen to just the right depth or filling with a dropper can be awkward at first.

### FOUNTAIN PEN

#### THE BEST OF BOTH WORLDS

RANGE OF NIB WIDTHS
.6 mm    to    2.7 mm

+ The thick metal nib is sturdy. The pen is simple to carry and ready to use. Half a dozen nib widths offer enough choice for beginners' handwriting and lettering projects. The reservoir is easy to fill from a bottle, or you can use foolproof ink cartridges.

− Fountain pen ink is transparent and often not fadeproof. Choice of ink colors is limited and basic. The nib is rigid and relatively blunt. Ink does not flow well through wide nibs, on the upstroke, or pointing uphill. Ink can leak when air pressure changes.

### MARKER

#### THE SIMPLE SOLUTION

RANGE OF NIB WIDTHS
2 mm    to    5 mm

+ The nib writes smoothly, even in large widths, on the upstroke, and pointing uphill. It is convenient to carry and effortless to use. It is cheap to buy and available everywhere. Ink does not leak out. Some inks are permanent, waterproof, and lightfast.

− Choice of nib width is limited to a few sizes. Ink colors are few and basic. Some of the nib fibers get mushy after a few uses. The nibs are generally too blunt for small detail. Ink can fade. When dried up, the ink cannot be refilled.

## MATERIALS LIST

PAPER *Use inexpensive copier paper for practice, vellum or bond for finished projects.*

PEN *Choose a marker or fountain pen for ease of use at first; use a fountain pen or dip pen for finished projects.*

MARKER    FOUNTAIN PEN    DIP PEN

INK *Markers are non-refillable. Fountain pen ink is water-based and transparent. Dip pens can use India ink.*

Fount

India

PENCIL *#2, #2½, or #3 lead.*

TAPE *Low-tack drafting tape, <u>not</u> masking or transparent.*

PAPER CLIPS *Small and flat.*

RULER *Metal or metal-edged.*

KNIFE *Razor or X-Acto.®*

ERASER *Kneadable and soft.*

## SETTING UP

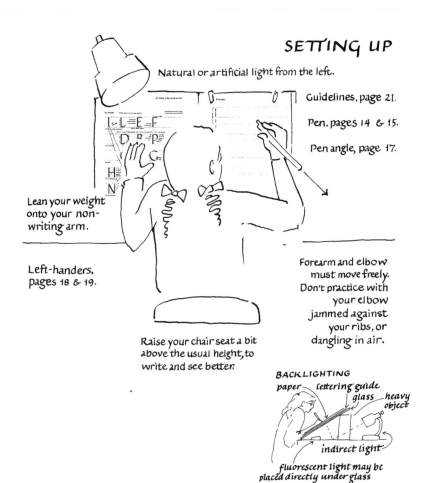

Natural or artificial light from the left.

Guidelines, page 21.

Pen, pages 14 & 15.

Pen angle, page 17.

Lean your weight onto your non-writing arm.

Left-handers, pages 18 & 19.

Forearm and elbow must move freely. Don't practice with your elbow jammed against your ribs, or dangling in air.

Raise your chair seat a bit above the usual height, to write and see better.

BACKLIGHTING

paper   lettering guide   glass   heavy object

indirect light

fluorescent light may be placed directly under glass

## WRITE FLAT OR SLANTED OR VERTICAL

*A slanted surface is a good compromise between a flat table and a vertical wall. You can buy an adjustable desk, or improvise your own by propping up a drawing board. Start with a slight incline. At steeper angles you may need to brace or hinge the bottom edge of the board to keep it from slipping forward. To make a light table, substitute thick glass, a large picture frame, or small window; light it from beneath.*

## PEN ANGLE

Each alphabet has a single* specified pen angle that makes the thicks and thins occur in the right places. Hold the pen at this angle throughout the _whole alphabet_. Each chapter specifies the correct pen angle to use with the letter style.

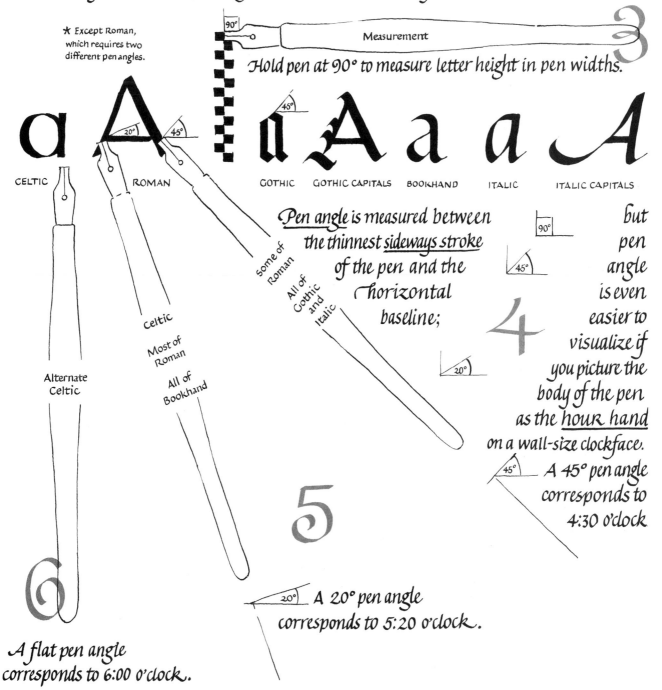

Incorrect        Correct

* Except Roman, which requires two different pen angles.

Measurement

Hold pen at 90° to measure letter height in pen widths.

CELTIC        ROMAN        GOTHIC    GOTHIC CAPITALS    BOOKHAND    ITALIC    ITALIC CAPITALS

Some of Roman

All of Gothic and Italic

Celtic

Most of Roman

All of Bookhand

Alternate Celtic

_Pen angle_ is measured between the thinnest _sideways stroke_ of the pen and the _horizontal_ baseline;

but pen angle is even easier to visualize if you picture the body of the pen as the _hour hand_ on a wall-size clockface.

A 45° pen angle corresponds to 4:30 o'clock.

A 20° pen angle corresponds to 5:20 o'clock.

A flat pen angle corresponds to 6:00 o'clock.

# LEFT HAND

Many left-handers curl
their hands around like this,
which makes the correct pen angle
but reverses the direction of the stroke,
turning natural <u>pulls</u> into awkward <u>pushes</u>.

## COMPENSATING FOR LEFT-HANDEDNESS

The major challenge for virtually all left-handers is the <u>pen angle</u>. (Minor issues include the way the hand smears the ink or hides the just-finished stroke.) Although the alphabets in this book are historically geared to right-handers, the left-handed beginner can compensate with a mix of these three strategies:

### 1.

The first solution to try is a different <u>paper position</u>. Rotate the page until the pen matches the correct angle for each alphabet you are learning (this angle is shown on each guideline page). A rotated page makes it physically comfortable to write the letter but hard to see.

Left-handers hold their pens at a variety of angles that can <u>not</u> be used to write the alphabets in this book correctly if the paper is straight. Look for your hand position below and reposition the paper as shown.

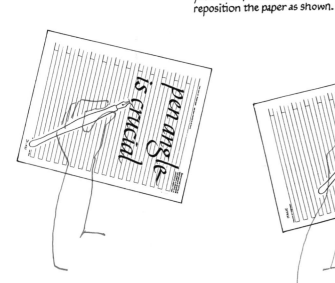

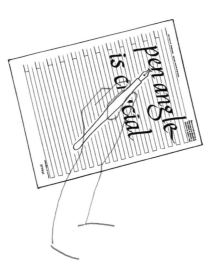

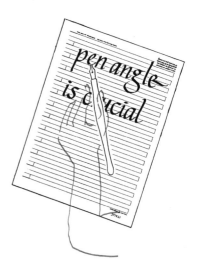

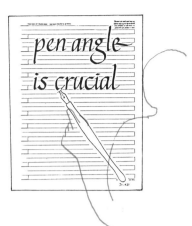

*pen angle is crucial*

Keep paper slightly to the left of your body.

**2.**
The second solution is to try different arm and <u>hand positions</u> while you keep the paper straight. Pull in your elbow and cock your wrist. This makes it easy to see the letter but awkward to write it.

File off a metal nib or buy one already oblique. A marker can be trimmed.

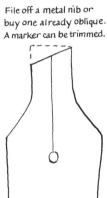

**3.**
The third solution to try is an <u>oblique nib</u>. This can help resolve the struggle between a comfortable writing position and an undistorted view of the practice page.

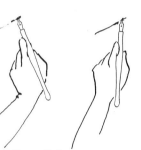

The oblique nib lets you make this pen angle . . . with this hand position.

## IF ALL ELSE FAILS

If none of these strategies feel comfortable to you, don't let the struggle with the pen angle prevent you from learning calligraphy. It is much better to <u>do without</u> thicks and thins, at first, than to learn them in the <u>wrong places</u>. You don't have to use a broad-edge pen at all to begin Roman, Book hand, Italic, and swashes.* Left-handers—and right-handers, for that matter, if pen angle is a stumbling block—can practice these alphabets with ballpoint, pencil, thinline marker, or fountain pen. After mastering the letters' basic structure, you can retry the broad-edge pen at the correct angle for the style.

*<u>Not</u> Celtic or Gothic.

# ROMAN bookhand Italic
A monoline pen can be held at any pen angle.

# ROMAN bookhand Italic
A broad-edge pen demands a specific pen angle.

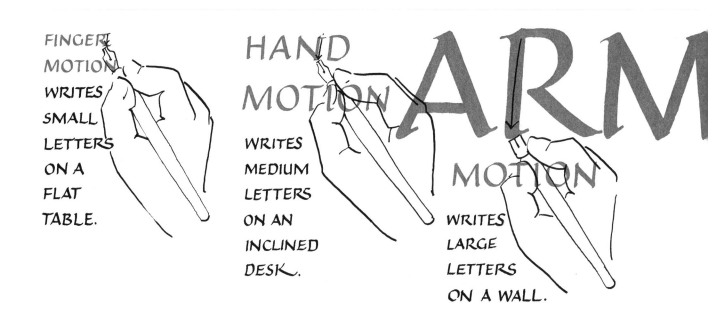

FINGER MOTION WRITES SMALL LETTERS ON A FLAT TABLE.

HAND MOTION WRITES MEDIUM LETTERS ON AN INCLINED DESK.

ARM MOTION WRITES LARGE LETTERS ON A WALL.

The steepness of the work surface will help you satisfy at least three* related demands: the eye should see clearly, the body should move comfortably, and the ink should flow smoothly.

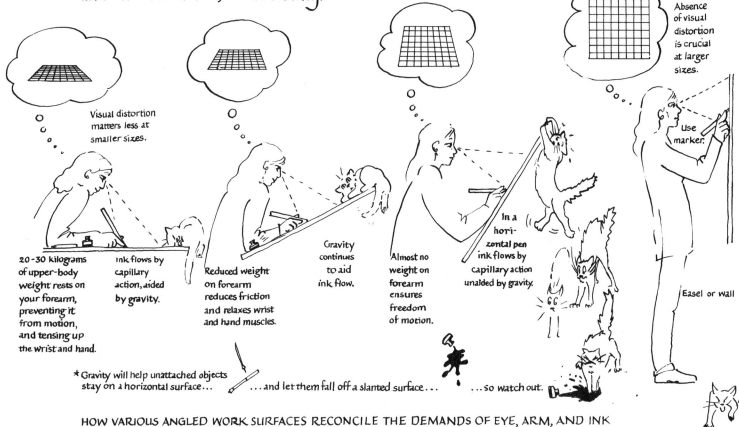

Absence of visual distortion is crucial at larger sizes.

Use marker.

Visual distortion matters less at smaller sizes.

20-30 kilograms of upper-body weight rests on your forearm, preventing it from motion, and tensing up the wrist and hand.

Ink flows by capillary action, aided by gravity.

Reduced weight on forearm reduces friction and relaxes wrist and hand muscles.

Gravity continues to aid ink flow.

Almost no weight on forearm ensures freedom of motion.

In a horizontal pen ink flows by capillary action unaided by gravity.

Easel or wall

* Gravity will help unattached objects stay on a horizontal surface... ...and let them fall off a slanted surface... ...so watch out.

HOW VARIOUS ANGLED WORK SURFACES RECONCILE THE DEMANDS OF EYE, ARM, AND INK

3 RULES ABOUT GUIDELINES Write on practice paper, not in the book.

Practice with guidelines, not on blank paper.

Practice with guidelines the right size for the pen & alphabet.

EIGHT WAYS TO MAKE GUIDELINES

2. Use a copy machine to run multiple copies of the guideline page provided for each chapter. (These are the only pages in this book that you may copy, and only for your own use.)

3. Buy a pad of ordinary blue-lined paper in a size to match your guidelines. For large letters, mark off 2 or 3 lines together.

1. Fasten thin paper over the guideline page so that the lines show faintly through.

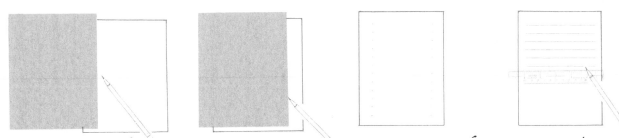

4. Use the edge of the guideline page as a ruler to measure a row of tic marks on the left and right margins of a blank sheet. Then connect them with pencil and straightedge.

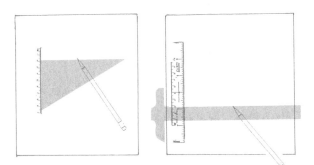

Cut slots. Pencil lines. Write letters. Let ink dry! Erase lines.

5. Rule larger paper with a T-square or triangle, penciling firm lines for practice, lighter ones to erase from finished work.

6. Make envelope address templates by cutting slots in stiff cards for pencil lines.

7. Type in and print out pages of hyphens & periods to suit your particular pen size.

8. Download and print out guidelines from the website: www.margaret shepherd.com

# DIAGNOSING THE MOST COMMON PROBLEMS

Using guidelines 8 times the height of the width of your chosen pen, practice a row of evenly spaced straight strokes.

Compare your practice strokes to the examples below, to identify and solve problems with either writing or seeing

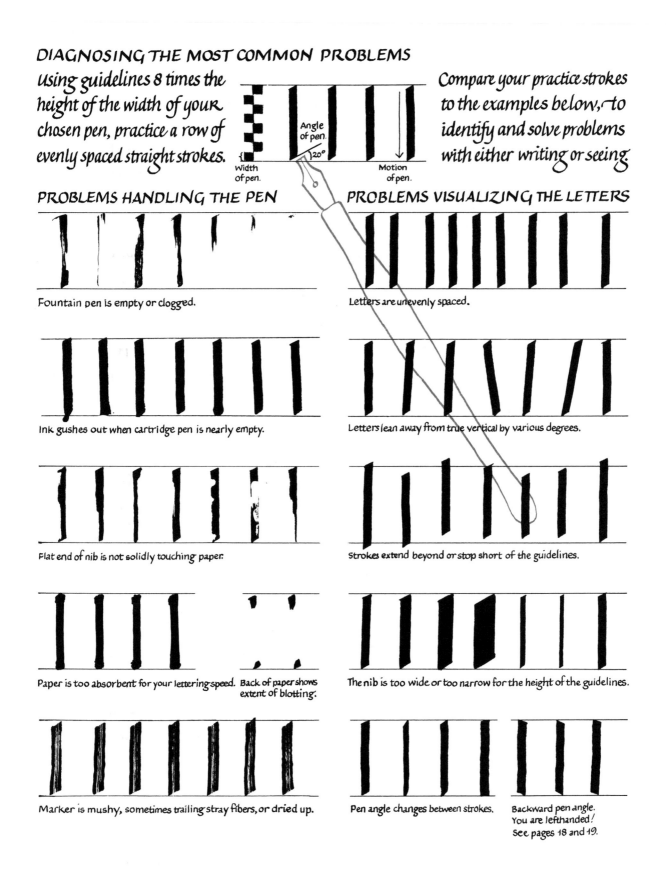

Width of pen. Angle of pen. 20° Motion of pen.

## PROBLEMS HANDLING THE PEN

Fountain pen is empty or clogged.

Ink gushes out when cartridge pen is nearly empty.

Flat end of nib is not solidly touching paper.

Paper is too absorbent for your lettering speed. Back of paper shows extent of blotting.

Marker is mushy, sometimes trailing stray fibers, or dried up.

## PROBLEMS VISUALIZING THE LETTERS

Letters are unevenly spaced.

Letters lean away from true vertical by various degrees.

Strokes extend beyond or stop short of the guidelines.

The nib is too wide or too narrow for the height of the guidelines.

Pen angle changes between strokes.

Backward pen angle. You are lefthanded! See pages 18 and 19.

# SEEING CALLIGRAPHY

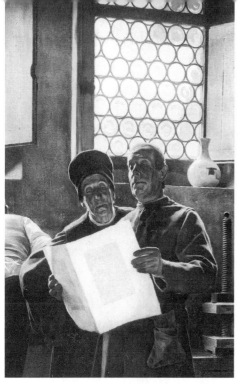

Calligraphy is a fine art like painting, sculpture, print-making, drawing, or photography—a way of seeing life and of telling what you see. The well-trained, intelligent, creative calligrapher can explore the world of visual art as thoroughly as any painter. Through calligraphy you can learn about proportion, color and line, positive and negative space, depth perception, and light. You can experiment with a wide variety of materials, work at any size from miniature to monumental, and letter in every genre from landscapes to portraits.

Calligraphy also has much in common with handicrafts and decorative arts such as stained glass, tapestry, goldwork, and bookbinding, where objects that are already useful are made beautiful, too. People respond to this quality of generosity, which elevates ordinary things by making them out of finer materials, with better workmanship, than their function requires.

Most calligraphy has a third dimension—literary. Your work carries an intellectual message in the content of its text. In presenting this text to the reader, you are like an actor speaking lines in a play; you strive to to help the audience understand the author's meaning, while you seek to deepen their appreciation (and your own) for what the art of calligraphy can do.

The best calligraphy has all three dimensions—a fine art, a craft, and a literary art. You, the calligrapher, bring together a striking visual idea, a high level of craftsmanship with fine materials, and a quotation chosen with care. But your work needs a further dimension—passion. You must have something to say. Show the reader why the text first caught your imagination, how the author's words spoke to you, what images you saw in your mind's eye. As you explore the other dimensions of calligraphy, don't forget the fundamental reason for every art— to speak from the heart, clearly, about what you have observed.

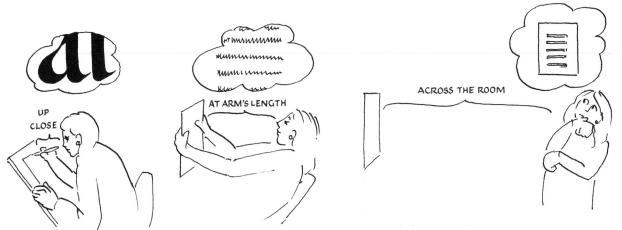

    While you write your calligraphy letter by letter, keep in
mind that your readers will see it as a whole. You communicate something to them
through the overall layout of the page, the skill and materials, and the choice of text,
plus the interaction among these three elements. Don't forget that you are usually
very close to the paper for hours when you letter; the details that seem so important
at ten inches are not what your readers will first notice at ten feet.

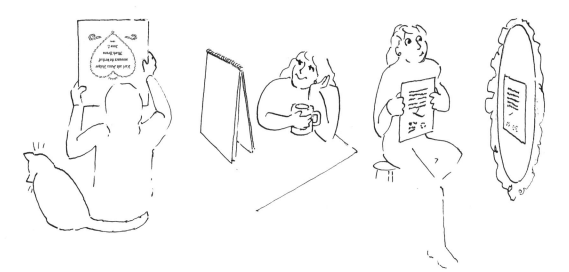

    To take a fresh look at your rough draft or finished page
(or to study other people's designs), get up from your chair and step into their
shoes. Stand where they stand; look through their eyes. Hold the paper at arm's
length. Tape it to the wall and back off. Squint at it. Turn it upside down. Look
at its reflection in a mirror. Glance at it. Stare at it. Go out for coffee and look
at it later. Try to SEE it for the first time.

The purpose of this book is to help you learn the basic letterforms of the broad pen alphabet and then arrange them into beautiful, interesting, original pieces of calligraphy. Beyond the shape of each individual letter, a good calligraphy design communicates on these levels:

LAYOUT. Is it balanced? Appealing? Challenging? Does the empty space help you read the lettered areas? Does the shape of the text make sense when you read the words? Is there variety as well as repetition? Do the colors and decoration stick out of the design or enhance it? Have you, the artist, learned something?

CRAFT. Does the letter style harmonize with the layout? Does it suit the period, subject, sentiments, or nationality of the text? Do the materials overwhelm the design with their richness or undermine it with their starkness? Is the quality of workmanship as good as the materials? Is the lifespan of the materials appropriate to the piece?

TEXT. Is the quotation a good choice? Well worded? Of enduring interest? Too brittle or too ponderous? Too short or too long? Too unfamiliar—or too familiar—to engage the reader's curiosity? Choose with sincere affection, as the author of a good quotation becomes your partner in the creative process.

Balanced      Unbalanced

Gesund-
heit!

German word, German letters

Gesund-
heit!

German word, Celtic letters

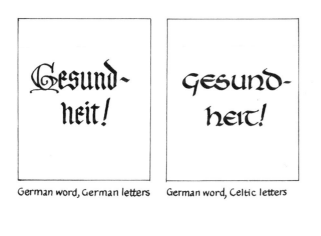

Life
is too short
to be small.

Elegant quote, elegant letters

You lie down
with the pigs,
you get up
smelling
like garbage.

Trivial quote, elegant letters

**SPACE**        *As you learn to look carefully at a piece of calligraphy both from ten inches and from ten feet, you will gradually recognize that the white shapes are just as real as the black strokes. The critical concept of <u>negative space</u> means that the empty space in and around the letters is as important as the letters.*

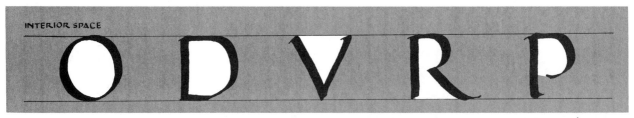

*First, look at the space <u>inside the letter.</u> Watch it take shape as you move the pen.*

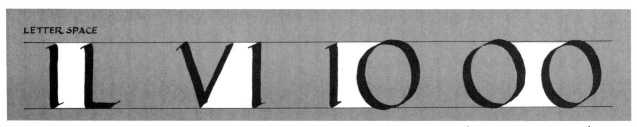

*Second, look at the space <u>between letters</u>. Learn to estimate the area, rather than the distance, between letters and between words.*

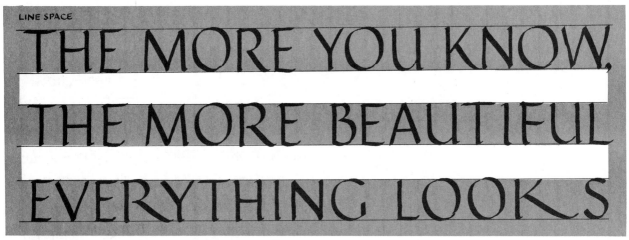

*Third, look at the space <u>between lines</u>.*

MARGINS

A SKILLED CRAFTSMAN IS TO BE TRUSTED IN HIS OWN ART

Fourth, look at the space between the text and the edge of the page. Visualize these margins in terms of positive & negative space when you plan your design.

As you learn to write the penstrokes that form each alphabet in this book, you will also be mastering the white spaces that are created by those strokes.

BALANCED

FLUSH LEFT

SHAPED

FREE-FORM

Thumbnail sketches help you visualize a variety of possible margins for your design.
BALANCED  Both left and right edges are straight, and centered on the page.
FLUSH LEFT  The right edge is ragged; the left edge is straight. (The reverse is rarer.)
SHAPED  The line length is controlled to make the words form objects or geometric shapes.
FREE-FORM  Both left and right edges are ragged. The whole page, however, is balanced.

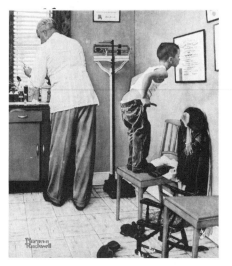

SPACE SURROUNDING THE READER AND THE PAGE
The spaces in & around the letters on the surface of the page are not the only spaces you bring to life with your pen. Calligraphy at its best opens up the space all around it, letting the people who look at it feel that they & the letters share a special world.   You can create this world if you

plan the design with its purpose clearly in mind. Visualize where it will be seen & what you can do to help it belong there.
 First, imagine or look at the actual place where the design will be displayed. How big is it, what are its proportions, what materials is it made of? How much light is there, what kind, from what angle? Will the letter style look right in the book or building that holds it?
 Next, put yourself in the viewers' shoes. How will they encounter your calligraphy: turning a page, meditating in church, strolling along a city sidewalk, sitting by a friend's hearth, clicking on an icon, opening an envelope? Will they see the design before they read its words, or read it before they really look at it?

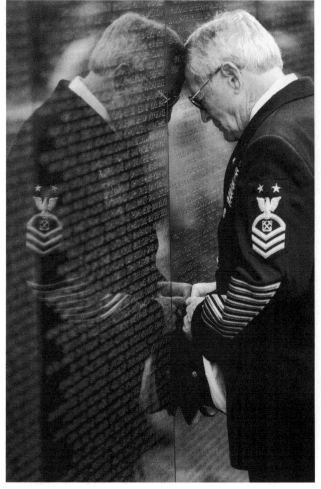

Finally, consider the viewers' likely state of mind. Will they be hurried or at leisure? Confident or anxious, joyful or in pain? Do they seek novelty or crave reassurance? Your calligraphy makes it easy for them to step into your world.

# ROMAN

ROMAN LETTERS, LIKE SO MUCH OF ROMAN CULTURE, EVOLVED FROM CENTURIES OF TRADE AND CON~ QUEST AROUND THE RIM OF THE MEDITERRANEAN SEA. THE IDEA OF SPELLING SOUNDS WITH LETTERS CAME FROM THE PHOENICIANS TO THE GREEKS, AND FROM THEM TO THE ROMANS. ▷ AS ROMAN POWER GREW & SPREAD, THE ALPHABET BECAME AN ESSENTIAL TOOL FOR MAIN- TAINING THE EMPIRE — ITS PROPAGANDA, MILITARY RECORDS, MONUMENTS, INSCRIPTIONS. IN THE FIFTEEN CENTURIES THAT FOLLOWED THE FALL OF ROME, EVERY REVIVAL OF CENTRALIZED POLITICAL POWER, EVERY RE- BIRTH OF PHILOSOPHY AND ART, REVIVED THE ROMAN ALPHABET TO MAKE ITSELF SEEM MORE LEGITIMATE. ◁ BEYOND ITS EVOCATION OF THE IMPERIAL PAST, THOUGH, THE ROMAN ALPHABET HAS SURVIVED TO BECOME THE WORLD'S STANDARD SCRIPT BECAUSE OF ITS STRENGTH, BEAUTY, AND RESILIENCE. IT IS EASY TO WRITE AND TO READ IN MANY MATERIALS, AT VIRTUALLY ANY SIZE. ▷

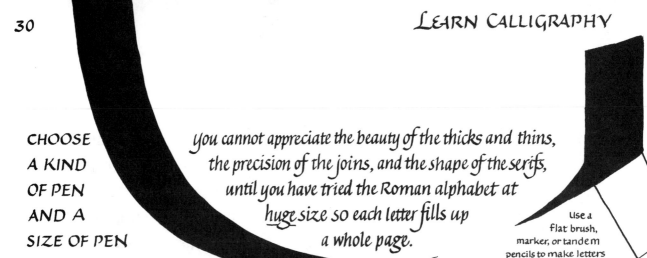

CHOOSE
A KIND
OF PEN
AND A
SIZE OF PEN

You cannot appreciate the beauty of the thicks and thins, the precision of the joins, and the shape of the serifs, until you have tried the Roman alphabet at _huge_ size so each letter fills up a whole page.

Use a flat brush, marker, or tandem pencils to make letters of monumental scale.

_Large_ letters encourage large arm motions and reveal details of construction, while allowing repetitive practice on reasonable-size paper.

# HEIGHT

If you have ever wanted to try a dip pen, now is the time. Because virtually all Roman strokes are pulled downwards, one by one, the friction and snags that handicap the dip pen in other alphabets won't trouble you here.

Dip pen or marker.

The letters in this chapter are illustrated at _medium_ size to show a great deal of detail while making them physically easy to practice.

You should resist the temptation to practice Roman letters at _small_ size, especially with a fountain pen or a marker, as you will grind in bad habits without being aware of them.

# HEIGHT

A good practice size for dip pen, fountain pen, or marker.

## HEIGHT

Dip pen or fountain pen.

### HEIGHT

### HEIGHT

You can _letter_ this small, but if you _practice_ this small, you won't learn anything useful.

HEIGHT

Dip pen.

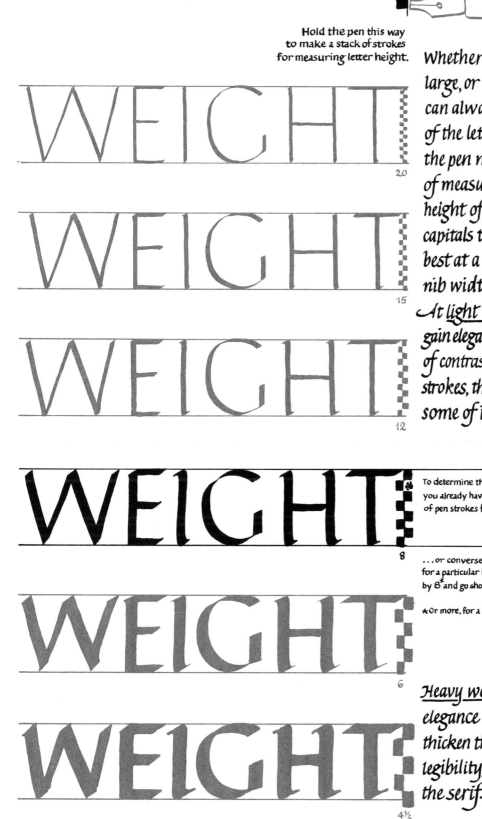

Hold the pen this way
to make a stack of strokes
for measuring letter height.

20

15

12

8

6

4½

Whether you practice at huge, large, or medium size, you can always choose the weight of the letter. The width of the pen nib is used as a unit of measure in relation to the height of the letter. Roman capitals traditionally look best at a height of 8 to 12 nib widths.

_At light weights_, Roman will gain elegance but lose the flow of contrasting thick and thin strokes, the unifying serif, and some of its visual strength.

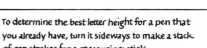

To determine the best letter height for a pen that you already have, turn it sideways to make a stack of pen strokes for a measuring stick...

...or conversely, to determine the best pen width for a particular letter height, divide that height by 8* and go shopping for a pen.

*Or more, for a lighter letter.

_Heavy weights_ diminish the elegance of the Roman letter, thicken the joins, decrease legibility, and overwhelm the serif.

## PEN ANGLE RULES

Roman capitals demand special attention to the pen angle. You cannot write the whole alphabet with the same pen angle. Most strokes are made with the pen at an angle of about 20°, while others require an angle of about 45° — don't let it waffle in between!

For extra help understanding pen angle, turn to page 17.

20°
pen angle

45° pen angle

The thick and thin strokes should be the same relative weight in both letters.

For most Roman letters, hold the pen at a 20° pen angle by moving your elbow near your ribs, or by aiming the pen shaft up toward your collar bone.

PRACTICE EXERCISE 1

When you see this symbol, practice at least 20 repetitions of the stroke or letter shown.

For a few of the letters, hold the pen at a 45° pen angle by moving your elbow away from your ribs or by aiming the pen toward your elbow.

PRACTICE EXERCISE 2

Letters with 45° pen angle strokes are clustered toward the end of the alphabet. Most, in fact, represent mainly later additions to Latin, brought in from Greek and elsewhere, and modified to make their diagonals harmonize with Roman verticals and horizontals.

## PEN ANGLE EXCEPTIONS

A few Roman letters contain a mix of 20° and 45° strokes, so that you have to change pen angles in the middle of a letter.

Watch out for places where strokes made with different pen angles meet or overlap. Precision is impossible, but you can take care to avoid gaps and tangles in the joins.

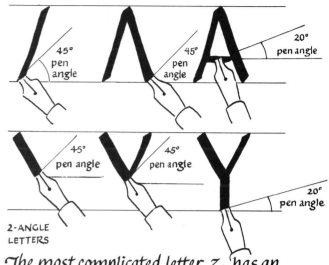

2-ANGLE LETTERS

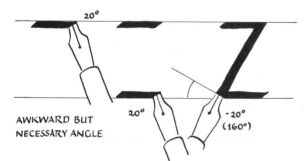

AWKWARD BUT NECESSARY ANGLE

The most complicated letter, Z, has an awkward, unique pen angle of backward 20° (actually 160°) to make its middle stroke fit in with the weight of the main strokes of all the other Roman letters.

The most subtle manipulation of pen angle by far, however, happens in the midstroke of Roman S. The pen must change angle throughout the curve, going smoothly from 20° to 45° and back again, to avoid thinning out and weakening the middle of the letter.

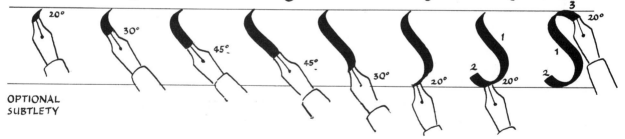

OPTIONAL SUBTLETY

When you begin to practice, be sure you do not change the pen angle without being aware of it. Many beginners put the heel of the hand firmly in one spot on the paper when they should be learning to move it along after two or three strokes.

If you don't move your hand across the paper as you letter, a 45° pen angle at the beginning will mutate gradually into an almost flat angle.

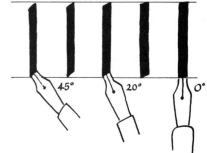

WRONG

*Virtually all Roman letters are put together from straight lines and sections of a circle.*

## BASIC ROMAN STROKES

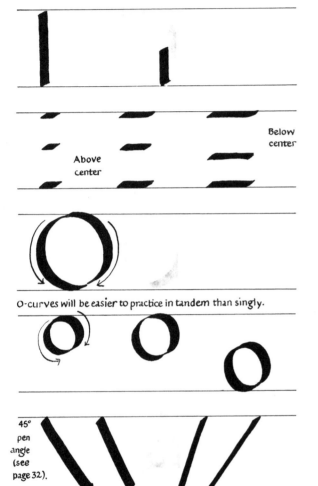

PRACTICE EXERCISE **3**

<u>Verticals</u> reach either full or half height.

Above center

Below center

PRACTICE EXERCISE **4**

<u>Horizontals</u> extend to a stub, short, or medium width at top, bottom, or middle level.

PRACTICE EXERCISE **5**

Large <u>O-curves</u> follow the outline of a circle the diameter of the letter's full height.

O-curves will be easier to practice in tandem than singly.

PRACTICE EXERCISE **6**

Small <u>O-curves</u> follow the outline of circles with diameters just under or over half height.

45° pen angle (see page 32).

PRACTICE EXERCISE **7**

<u>Diagonals</u> lean left or right at several different steep or moderate slopes.

HYBRID STROKES *combine lines and curves. Diagonals with a shallow slope end with a barely perceptible bend. The <u>S</u> curve begins and ends a steep diagonal with 2 short sections of the small circle.*

PRACTICE EXERCISE **8**

PRACTICE EXERCISE **9**

BASIC ROMAN JOINS    *The basic strokes on the facing page join each other in four different ways to make the 26 letters of the Roman alphabet.*

*Two curves, or a curve and a straight stroke, can <u>touch</u> at their sharp points.*

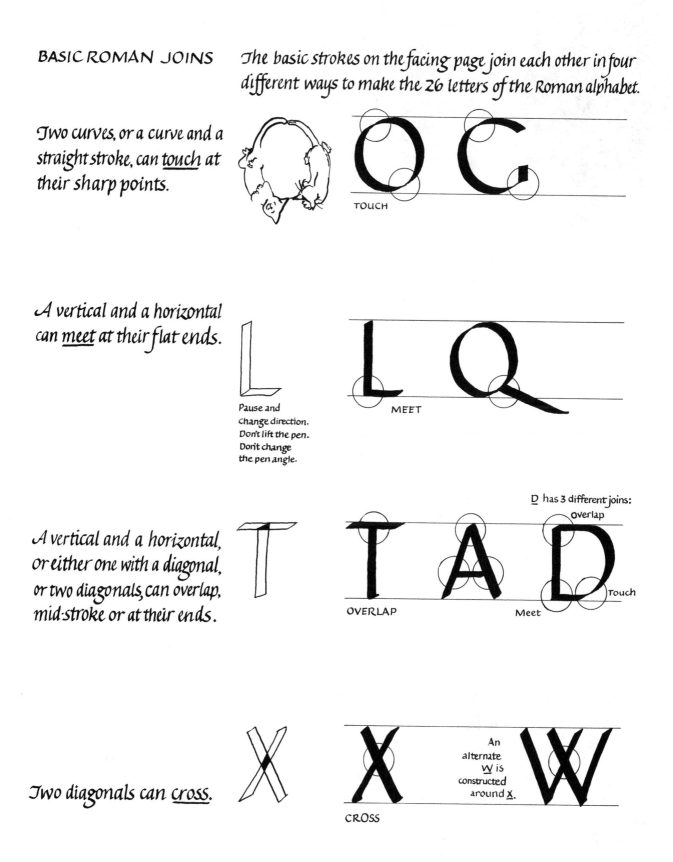

TOUCH

*A vertical and a horizontal can <u>meet</u> at their flat ends.*

Pause and change direction. Don't lift the pen. Don't change the pen angle.

MEET

*D has 3 different joins:*
overlap

*A vertical and a horizontal, or either one with a diagonal, or two diagonals, can overlap, mid-stroke or at their ends.*

OVERLAP          Meet          Touch

*Two diagonals can <u>cross</u>.*

An alternate <u>W</u> is constructed around <u>X</u>.

CROSS

## PROPORTIONS

The Roman alphabet is based on careful attention to the proportions of the letters; they are all the same height but they vary in width.

Note that these categories concern only the width of the letters, not pen angle (page 32) or spacing (pages 42-43).

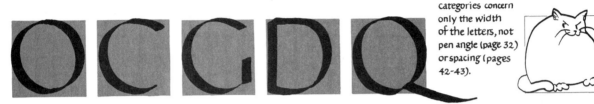

These letters are exactly as wide as their height. They fit inside a square.

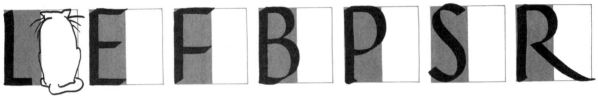

These letters are half as wide as their height. They fill half a square.

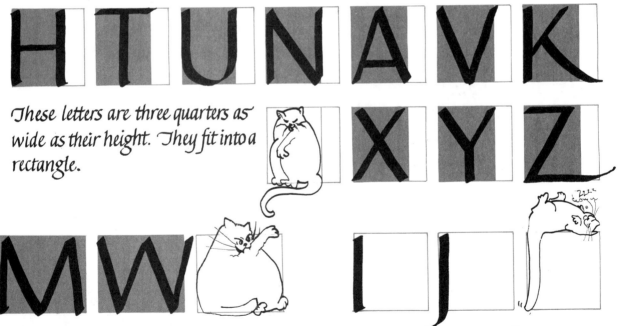

These letters are three quarters as wide as their height. They fit into a rectangle.

These letters are wider than a square.

These letters are the width of one stroke.

## ROMAN VISUAL SUBTLETIES

While Roman letters may seem to rely on a purely geometric structure, they in fact use many subtle visual compromises.

Letters that appear to be divided exactly in half really cross just slightly above . . .

. . . or below the geometric center.

H B X
F P A

Tom Costello

Thick, curved strokes that form the leg or tail of K, Q, and R are in fact mainly straight, and curve a little at the very end.

Do not let the tail get too thick for the letter.

C and G follow the asymmetrical outline of an egg, not the symmetrical outline of a circle. Many other Roman letters are slightly adjusted from geometry.

Calligraphers have searched for 2000 years to find a system for the Roman letter that accommodates the ideals of pure geometry to the realities of the human mind and eye.

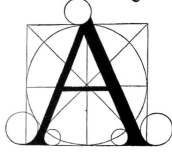

## ROMAN
Similar letters are grouped together.

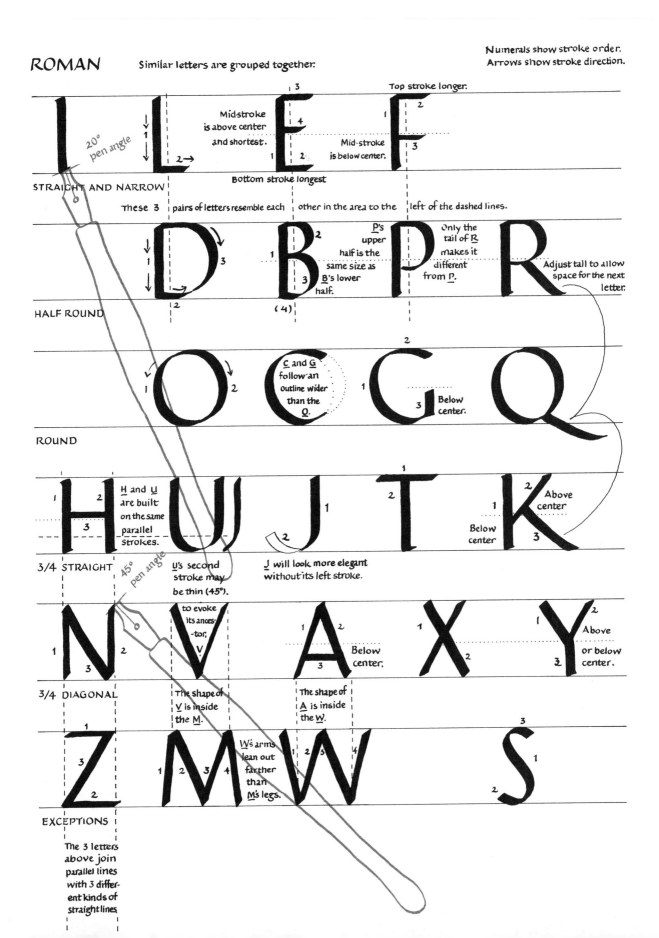

**STRAIGHT AND NARROW**

Midstroke is above center and shortest.
Bottom stroke longest.
Top stroke longer.
Mid·stroke is below center.

These 3 pairs of letters resemble each other in the area to the left of the dashed lines.

**HALF ROUND**

P's upper half is the same size as B's lower half.
Only the tail of R makes it different from P.
Adjust tail to allow space for the next letter.

**ROUND**

C and G follow an outline wider than the Q.
Below center.

**3/4 STRAIGHT**

H and U are built on the same parallel strokes.
Above center
Below center

45° pen angle
U's second stroke may be thin (45°).
J will look more elegant without its left stroke.

**3/4 DIAGONAL**

to evoke its ances-tor, V
Below center.
Above or below center.

The shape of V is inside the M.
The shape of A is inside the W.

**EXCEPTIONS**

W's arms lean out farther than M's legs.

The 3 letters above join parallel lines with 3 different kinds of straight lines

Large size
medium size

small

medium size

Large size
medium size

medium size

Large size
medium size

medium size

Large size
medium size

Use a copier or scanner
to enlarge or reduce the
guidelines to fit the width
of the pen you are using

The entry serif gets the ink flowing
and bridges the gap in the nib.

## SERIFS

*A serif finishes off the stroke ends with
a small sideways motion that serves many
purposes. It covers the central nib split
at the start of the stroke and distributes
the accumulated ink at the end; it rounds
off the corners of angular spaces both in
and between letters; it expresses the under-
lying motions of the pen from stroke to
stroke; and it gives the 26 individualistic
letters of the Roman alphabet a unified
style to wear on their hands and feet.*

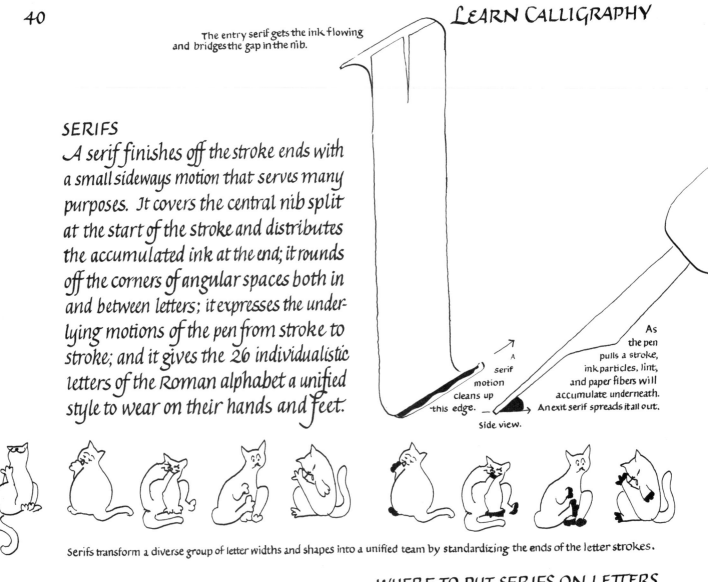

A
serif
motion
cleans up
this edge.

Side view.

As
the pen
pulls a stroke,
ink particles, lint,
and paper fibers will
accumulate underneath.
An exit serif spreads it all out.

Serifs transform a diverse group of letter widths and shapes into a unified team by standardizing the ends of the letter strokes.

PRACTICE
**10**
EXERCISE

OPTIONAL
EXERCISE

To make this little
triangular serif.
lean onto the right nib corner
as you move it down and lift
the pen off the paper.

## WHERE TO PUT SERIFS ON LETTERS

*Serifs <u>belong</u> on the ends of vertical and
diagonal strokes that do not already meet
or touch another stroke. Overlap is O.K.*

*Serifs are <u>optional</u> on the unattached
ends of horizontal strokes. Choose from
two forms for the right end of the stroke.*

*Serifs <u>do not belong</u> on tails, joins, or the
thin ends of curved strokes.*

Keep your Roman serif small at first, so as not to slow down or disrupt either your physical rhythm of writing or your reader's visual rhythm of reading.

A simple serif is shown in detail at right and applied to a basic alphabet below.

Visualize a center line.

Curve stroke to intersect guideline and center line.

Serif is made of small curve plus hairline.

Practice serifs in separate strokes, repeated single letters, letter families, words, sentences, and whole pages. <u>Then</u> write in alphabetical order.

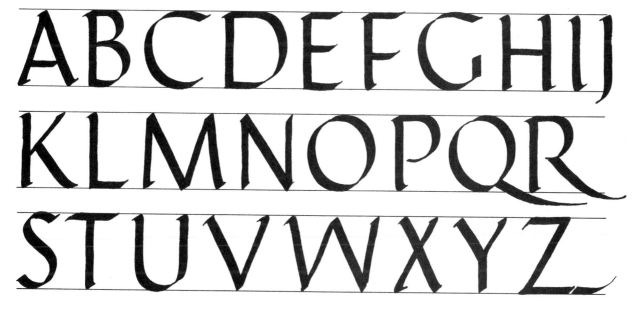

ABCDEFGHIJ
KLMNOPQR
STUVWXYZ

HAIRLINE

CALLIGRAPHY WRITTEN WITH A PEN USUALLY HAS A SERIF.

CURVE

CALLIGRAPHY WRITTEN WITH A PEN USUALLY HAS A SERIF.

SLAB

CALLIGRAPHY WRITTEN WITH A PEN USUALLY HAS A SERIF.

OFFSET SLAB

CALLIGRAPHY WRITTEN WITH A PEN USUALLY HAS A SERIF.

COMPOUND

CALLIGRAPHY WRITTEN WITH A PEN USUALLY HAS A SERIF.

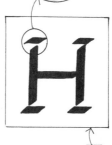

OPTIONAL EXERCISE

## SPACING

To space the Roman letters evenly, you must train your eye to estimate the <u>area</u>—not the distance—between the right edge of the last letter and the left edge of the next. Visualize the spaces between Roman letters as ant farms, where each different shape is filled up with the same amount of sand.

The 26 letters combine to make 676 pairs, of which most are duplicates. Some 2 dozen <u>kinds</u> of letter spaces are formed by strokes classified as straight, convex, or concave.

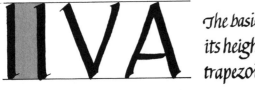

The basic unit of spacing is a rectangle a little wider than half its height. The eye then visually "pours" this amount into the trapezoids and parallelograms made by <u>straight</u> strokes.

The <u>convex</u> strokes of the closed round letters make spaces that resemble croissants and hourglasses.

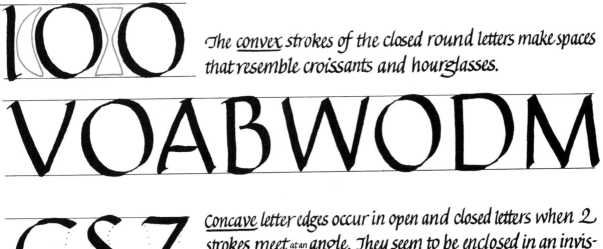

<u>Concave</u> letter edges occur in open and closed letters when 2 strokes meet at an angle. They seem to be enclosed in an invisible elastic boundary that can bulge out or suck itself in.

# ...CING

PRACTICE EXERCISE 11

Practice larger than shown.

Practice letter spacing at medium height, starting with the groups shown reduced at right. Don't rush through this part of learning the Roman alphabet nor undervalue its importance. Roman depends on beautiful, intelligent, intuitive spacing more than any other alphabet you will study in this book.

## WORD SPACING

The space between words should be about equal to the O.

# SPACE IT WITH O

## VARIABLE SPACING

You can move all the letters and words closer together, to darken the texture and make the line of lettering shorter.

# SPACE IT IN

Or you can move all the letters and words farther apart, to lighten the texture and make the line of lettering longer.

# SPACE IT OUT

AHVHAH
AVAVAVA
VOAOVO
DODODO
PAPVPAPV
STSLTSLS
TVTATVTA
LATLTALAT
EFELEFELF
CCTCACV
QURVRAR

SPACING PRACTICE

ETCETERA
SPACING
CALLI-
GRAPHY

## CHOOSING A TEXT

Roman letters are a natural choice for texts of serious tone, stately pacing, dignified phrasing, and enduring importance. Use Roman for shorter rather than longer passages, from a single capital or a few letters to a dozen lines or so. Make longer quotations more inviting to the eye by varying the letter size. Stick with prose that you can justify rather than poetry that must remain uneven at the right margin. Choose Roman capitals for monuments, title pages, bookplates, monograms, memorials, logos, letterheads, and, of course, any quotation in Latin.

"HOT TUB
Salt water
and fresh"

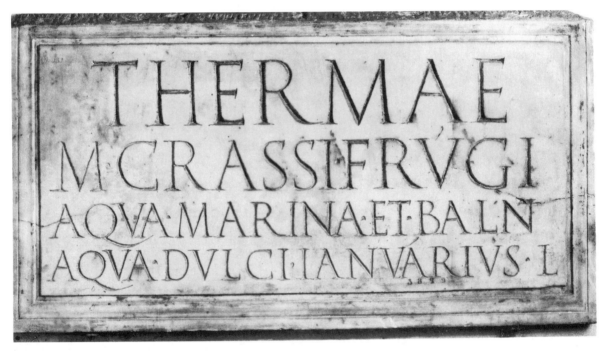

Roman letters look most authentic when the space between the lines is narrower than the height of the letters themselves.

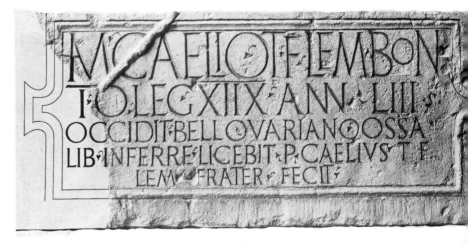

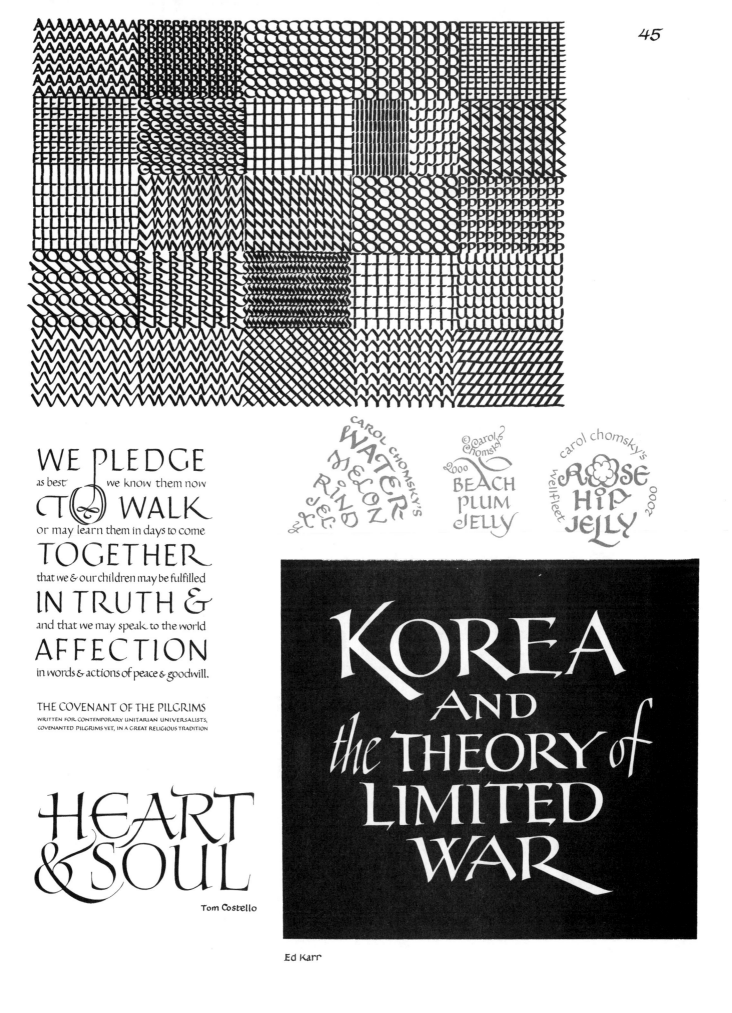

WE PLEDGE
as best we know them now
CTO WALK
or may learn them in days to come
TOGETHER
that we & our children may be fulfilled
IN TRUTH &
and that we may speak to the world
AFFECTION
in words & actions of peace & goodwill.

THE COVENANT OF THE PILGRIMS
WRITTEN FOR CONTEMPORARY UNITARIAN UNIVERSALISTS,
COVENANTED PILGRIMS YET, IN A GREAT RELIGIOUS TRADITION

CAROL CHOMSKY'S
WATER
MELON
RIND
JELLY

© carol
chomsky's
2000
BEACH
PLUM
JELLY

carol chomsky's
wellfleet
ROSE
HIP
JELLY
2000

HEART
& SOUL

Tom Costello

KOREA
AND
the THEORY of
LIMITED
WAR

Ed Karr

**AFTER ROMAN**     In the waning days of the Roman Empire, all over its former dominions, the capital letters that had once seemed eternal started to change. Far from home and influenced by local styles, the exquisitely proportioned alphabet of narrow letters, medium letters, and wide letters gradually deteriorated into several visually naive alphabets where either all the letters were narrow or all the letters were wide. Narrow Roman, called Rustica for its resemblance to the vertical Etruscan runes of northern Italy, requires a single steep pen angle of nearly 60°.

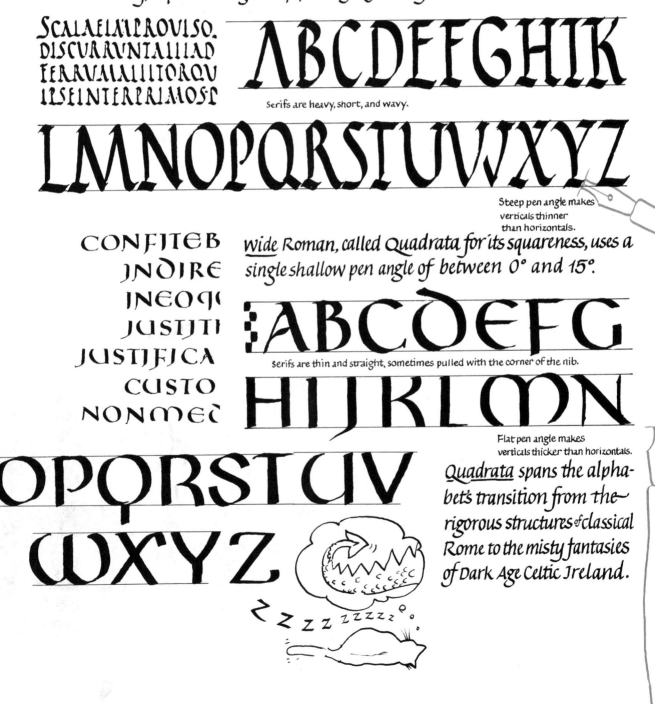

ABCDEFGHIK

Serifs are heavy, short, and wavy.

LMNOPQRSTUVWXYZ

Steep pen angle makes verticals thinner than horizontals.

Wide Roman, called Quadrata for its squareness, uses a single shallow pen angle of between 0° and 15°.

ABCDEFG

Serifs are thin and straight, sometimes pulled with the corner of the nib.

HIJKLMN

Flat pen angle makes verticals thicker than horizontals.

Quadrata spans the alphabet's transition from the rigorous structures of classical Rome to the misty fantasies of Dark Age Celtic Ireland.

OPQRSTUV

WXYZ

zzzz zzzzz

# Celtic

## After the decline of the Roman Empire,

other countries adopted the Roman letter, tailoring it to suit their social purposes and artistic styles. When St. Patrick introduced Christianity into Ireland in A.D. 500, he brought with him texts in Quadrata, the rounded and simplified version of Roman capitals. The Celts copied these scriptures, rounding the letters even more to go with Celtic coils and spirals. At the same time, the scribes employed a local script — Runes, a Viking alphabet outside the Roman tradition. Originally scratched into wood, stone, or metal,

## THE STRAIGHT LINES OF RUNES

transformed the imported Roman capitals into a nearly abstract alphabet that contrasts dramatically with the curved text letter.

# CHOOSE A KIND OF PEN AND A SIZE

Celtic offers a different lesson at each different size.

IMPACT     PRECISION           SPONTANEITY         FIT

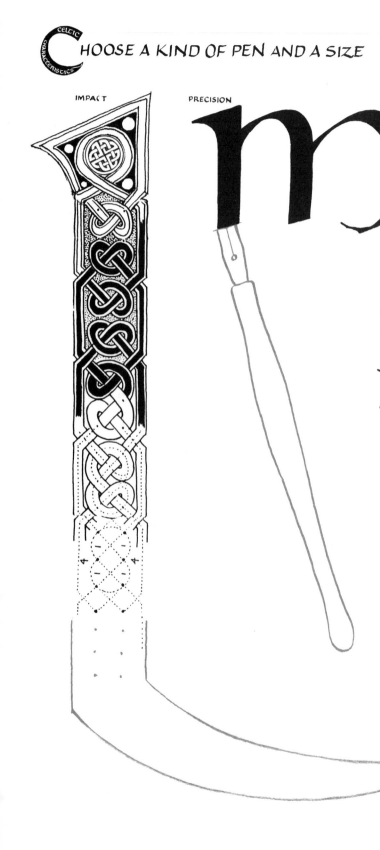

A <u>small</u> marker or fountain pen lets you create variations on the basic shape by writing faster and more casually.

A <u>medium</u>-size letter, written carefully with a wide fountain pen or dip pen, lets you form the serifs and joins with precision.

You can write the strokes of the largest Celtic letters using tandem pencils, a <u>huge</u> dip pen, a flat brush, or an over-size marker. Traditionally, however, page-size letters were outlined and filled in with color, gold, & complex ornament.

# TEN CELTIC CHARACTERISTICS

No single characteristic is essential,
but together they define the Celtic style.

In place of firm rules and practice exercises, this letter style depends on each calligrapher's combination of the ten main characteristics. Conveniently, they all start with the letter C: comfort at all sizes, choice of weights, changeable pen angle, compound serifs, chunky extenders, common case font, cute proportions, coils that continue, curves that stretch, and contained spaces. Study the characteristics summarized here and detailed in the next six pages. Pay attention to them while you learn the basic Celtic alphabet, choosing the characteristics that seem important to you after you read about them in detail.

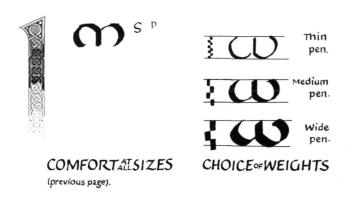

COMFORT AT ALL SIZES
(previous page).

CHOICE OF WEIGHTS

Thin pen.

Medium pen.

Wide pen.

two strokes overlapping

short

capital and small letters of the same height

CHANGEABLE PEN ANGLE    COMPOUND SERIFS    CHUNKY EXTENDERS    COMMON CASE FONT

CUTE PROPORTIONS    COILS THAT CONTINUE    CURVES THAT STRETCH    CONTAINED SPACES

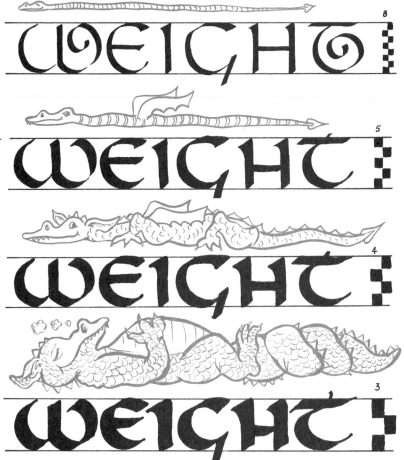

**WEIGHT**

**WEIGHT**

**WEIGHT**

**WEIGHT**

## CHOICE OF WEIGHTS

Celtic letter weight is a trade-off, not a formula. In deciding between heavier or lighter weight, the scribe balances impact vs. elegance, power vs. nimbleness, the loud vs. the articulate. Celtic letters are easiest to learn at medium weight; they can, however, add or lose a few pounds and still please the eye, read clearly, and look every bit as Celtic.

## CHANGEABLE PEN ANGLE

The most historically authentic Celtic letters use a flat, 0° pen angle that aims the pen up and down, like the hour hand of a clock at 6:00. But you can adapt the letters to a more comfortable pen angle of 15° ~ 30°, which is used in this chapter. It is a matter of personal choice.

3 ways to write with a flat angle:

keep your elbow up against your ribs; or

rotate both your arm and your paper; or

use an oblique pen point to reconcile arm comfort with level paper.

**PRACTICE EXERCISE 1**

Try each basic stroke, watching the stroke endings and where the thicks and thins occur.

**OPTIONAL EXERCISE**
A flatter pen angle changes the basic strokes slightly. . .

**OPTIONAL EXERCISE**
. . . and the flattest pen angle changes the basic strokes even more.

**CONTINUOUS PEN ANGLE CHANGE**
In advanced Celtic technique, the pen angle actually changes while you letter, making a stroke that is slanted at the top and square at the bottom.

ABCDEFGHIJKLMNOPQRSTUVWXYZ

**VERTICAL SERIF**

whichever stroke
you start with,
these thin lines
will help you
position the other
stroke accurately.

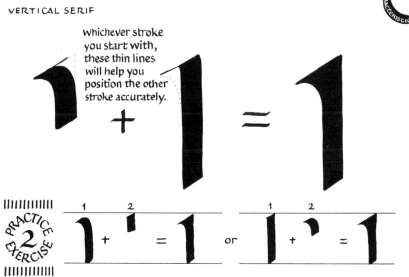

## COMPOUND SERIF

*The distinctive wedge-shaped serif is built up from one straight stroke and one curved one. They overlap at the top of most vertical letter-strokes and a few diagonals.*
*Practice to achieve precision.*
*A uniform serif will give your alphabet of widely differing letters an overall Celtic "look."*

PRACTICE EXERCISE 2

ABCDEFGHIJKLMNOPQRSTUVWXYZ

**HORIZONTAL SERIF**

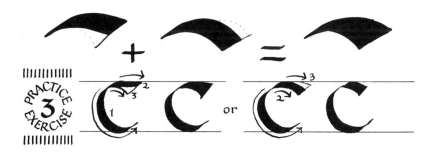

PRACTICE EXERCISE 3

*Supplement the vertical serif with one built up from two horizontal strokes. At heavier line widths you may not need much extra serif build-up or any at all.*

ABCDEFGHIJKLMNOPQRSTUVWXYZ

FOOT

touch       overlap

OPTIONAL EXERCISE

*An optional flat serif may be added to accentuate the free end of a curved stroke.*

## CHUNKY EXTENDERS

*The strokes that extend up and down from the letter body do not reach very far—just enough to distinguish similar letters from each other. And even though short extenders let you squeeze lines of Celtic lettering together to create a dense texture on the page, when you spread the lines apart, these extenders still cling close to their letters.*

This little stroke keeps
T from resembling C.

D traditionally
goes across, not up.

# extender

A little extra height is all that distinguishes
H from otherwise identical N.

# height is

This is short
and snug.

# kept low

This stroke can be shorter if this one is included.

DISTANT
SPACING
OF LINES

DENSE
SPACING
OF LINES

## COMMON CASE FONT

*By compressing the extenders of some letters & cutting off the extenders of others (above), Celtic scribes created letters that are not strictly capital or lowercase, but a blend of both. These hybrids are freely mixed together with capital and lowercase forms between the same guidelines. Some letters appear in several different versions on the same page and in the same word.*

# CAPITAL ROMAN

↓

# common case celtic

# mixes capitals, small

# letters, and hybrids

↑

# lowercase bookhand

# CUTE PROPORTIONS

Celtic letters express their playfulness in countless ways: tangling stretching and coiling; sprouting faces and feet; morphing into animals, people, and birds. Celtic manuscripts are so thickly carpeted with ornament, it sometimes threatens to upstage the text. The beginning calligrapher may start to think of the ornament as fun and the alphabet as work.

Luckily, however, the playful nature of Celtic does not, in fact, depend on extra ornament but is built into the very structure of the letter shapes themselves. Celtic proportions bring many letters to life with the unmistakable cuteness of baby animals. Three specific principles help create the appealing illusion:

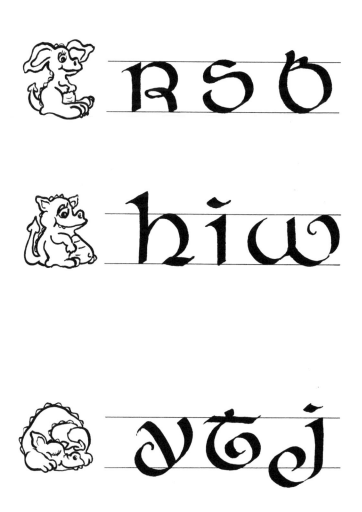

Young creatures look cute because their <u>heads</u> are big and their <u>bellies</u> are soft. Letter bodies can mimic these baby bodies with top- or bottom-heavy proportions and bulgy curves.

Young creatures look cute because their <u>ears and feet</u> are too big for their bodies. Letters can evoke this gentle clumsiness with big serifs (page 51) and naive little decorative strokes.

Young creatures look cute because whenever they feel vulnerable, they stay warm and safe by <u>curling up</u>. Celtic letters can curl up, too (page 54), to create an air of innocent trust that appeals to the reader's instinctive emotional response to a sleeping baby—even a baby letter!

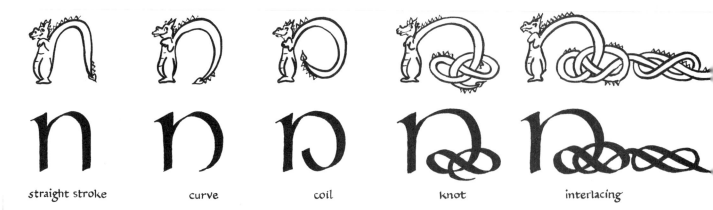

straight stroke          curve          coil          knot          interlacing

# COILS THAT LENGTHEN

Many Celtic letters start or finish with a curve where other letters are straight. Some of these curves <u>keep going</u> to form Celtic coils & knots that fill the space inside the letter after they have formed it. If you need a thinner line, turn the pen slightly so that only a corner of the nib touches the paper. Or simply come back later to fill the space with a different pen or brush (see far right, top). ⟶

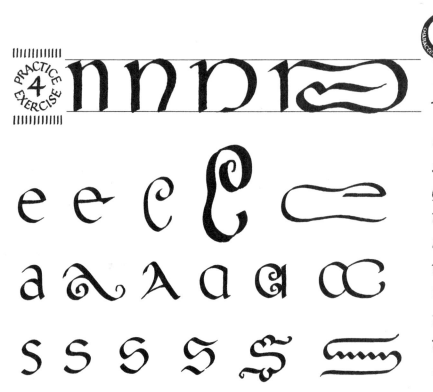

PRACTICE EXERCISE 4

# CURVES THAT STRETCH

While the strokes that form each letter can add length (above) that curls around to fill the space inside the letter, they can also <u>expand the space</u> inside the the letter. Some letters are irrepressible exhibitionists who can't resist spreading their wings when they find themselves with a little extra space at the end of a line ⟶

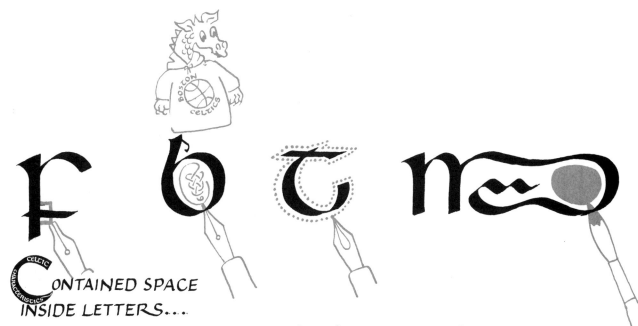

**CONTAINED SPACE INSIDE LETTERS....**

Celtic calligraphy creates rounded spaces inside the letters, which Celtic ingenuity finds many ways to fill. In addition to the coils & curves made by the calligraphy pen (previous page), the space inside the letter can be filled with a variety of thinner pen strokes, outlined ornament, dots, solid color, and gold leaf. The decorations were traditionally added by an artist other than the scribe, using specialized tools and materials (pages 88 and 89).

**...AND SPACE BETWEEN LETTERS**

Celtic spacing between the letters can be as elastic as the shape of the letters themselves. Choose spacing that expresses the tone of voice you hear when you read the text, while anticipating how familiar your reader already is with the words.

ISOLATED

NEARLY TOUCHING

TOUCHING & OVERLAPPING

## CELTIC

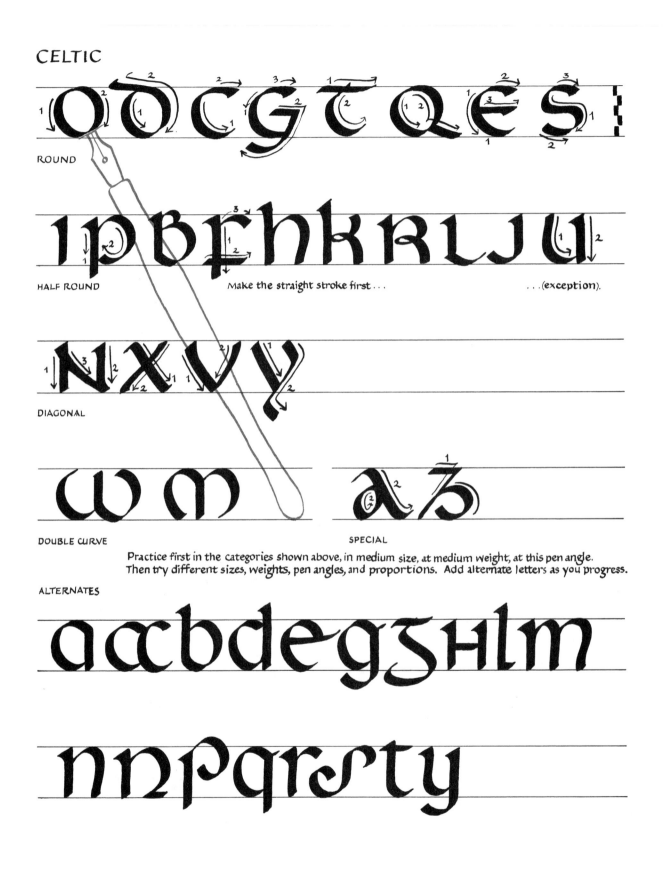

ROUND

HALF ROUND          Make the straight stroke first . . .                    . . . (exception).

DIAGONAL

DOUBLE CURVE                          SPECIAL

Practice first in the categories shown above, in medium size, at medium weight, at this pen angle.
Then try different sizes, weights, pen angles, and proportions. Add alternate letters as you progress.

ALTERNATES

Use a copier or scanner
to enlarge or reduce the
guidelines to fit the width
of the pen you are using.

LOOK MORE KEENLY AT IT
AND YOU WILL PENETRATE
THE VERY SHRINE OF ART

YOU WILL MAKE OUT IN
TRICACIES, SO EXACT AND
COMPLEX, SO FULL OF
KNOTS AND LINKS, WITH
COLORS SO FRESH, THAT

12TH CENTURY

YOU MIGHT SAY THAT ALL
THIS WAS THE WORK OF an
ANGEL & NOT OF A MAN.

## CHOOSING A TEXT

Celtic letters bring a fresh and idiosyncratic visual style to the page as well as historical associations with the Dark Ages and all things Irish. Choose Celtic for scripture, short sayings, old Celtic texts, new Irish writers, logos, and headlines. With lengthy texts, help the reader decipher easily by choosing plainer letters as alternates, "justifying" both margins, and spacing the letters evenly.

Tom Costello

O TO BE A DRAGON
FOR WOMEN'S CHORUS AND PIANO

Text by Marianne Moore
Music by Yehudi Wyner

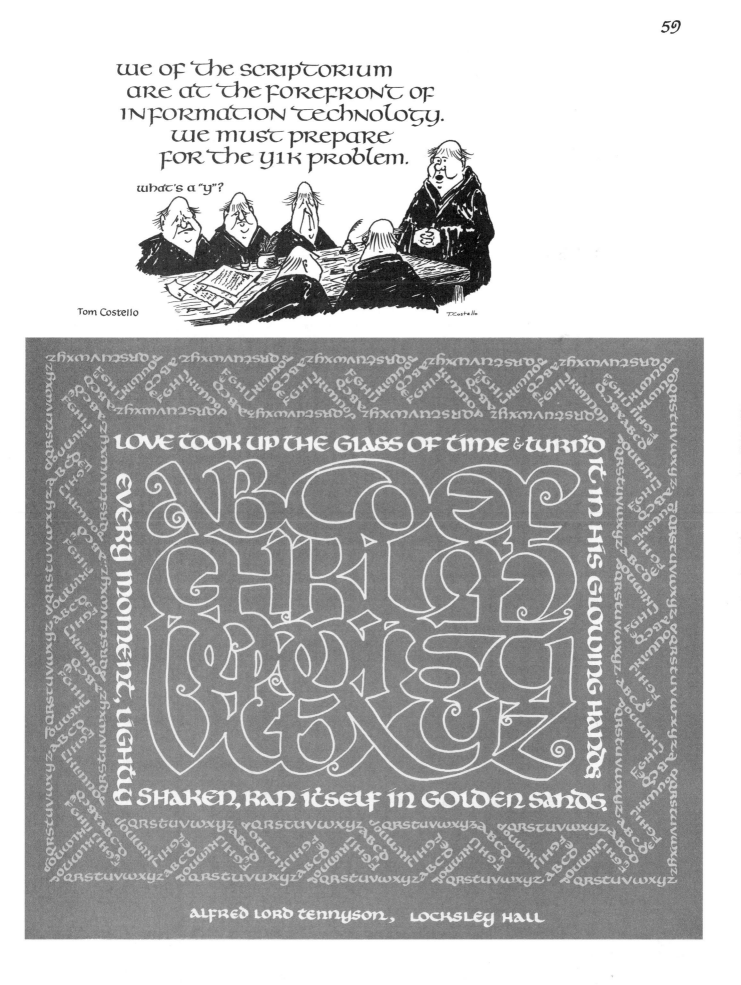

WE OF THE SCRIPTORIUM ARE AT THE FOREFRONT OF INFORMATION TECHNOLOGY. WE MUST PREPARE FOR THE Y1K PROBLEM.

what's a "y"?

Tom Costello

LOVE TOOK UP THE GLASS OF TIME & TURN'D IT IN HIS GLOWING HANDS EVERY MOMENT, LIGHTLY SHAKEN, RAN ITSELF IN GOLDEN SANDS.

ALFRED LORD TENNYSON, LOCKSLEY HALL

dream

a dream

HAVE
A DREAM

HAVE
A DREAM
COME TRUE

HAVE A
DREAM COME
TRUE
?

YOU GONNA
HAVE A DREAM
COME TRUE?

HOW YOU GONNA
HAVE A
DREAM
COME TRUE?

IF YOU DON'T
HAVE A DREAM,
HOW YOU GONNA
HAVE A DREAM
COME TRUE?

YOU'VE GOT TO
HAVE A DREAM;
IF YOU DON'T
HAVE A DREAM,
HOW YOU GONNA
HAVE A DREAM
COME TRUE?.

ABCDEFGHIJKLMNOPQRSTUVWXYZABCDEFGHIJ
ABCDEFGHIJKLMNOPQRSTUVWXYZABCDEFGHIJ
ABCDEFGHIJKLMNOPQRSTUVWXYZABCDEFGHIJ
ABCDEFGHIJKLMNOPQRSTUVWXYZABCDEFGHIJ
ABCDEFGHIJKLMNOPQRSTUVWXYZABCDEFGHIJ
ABCDEFGHIJKLMNOPQRSTUVWXYZABCDEFGHIJKLMNOPQRSTUVWXYZ
ABCDEFGHIJKLMNOPQRSTUVWXYZABCDEFGHIJKLMNOPQRSTUVWX
ABCDEFGHIJKLMNOPQRSTUVWXYZABCDEFGHIJKLMNOPQRSTUV
ABCDEFGHIJKLMNOPQRSTUVWXYZABCDEFGHIJKLMNOPQRSTUV
ABCDEFGHIJKLMNOPQRSTUVWXYZABCDEFGHIJKLMNOPQRS
ABCDEFGHIJKLMNOPQRSTUVWXYZABCDEFGHIJKLMNOPQRS
ABCDEFGHIJKLMNOPQRSTUVWXYZABC

BEWARE THE IDEAS OF MARCH

HAPPY
TALK
KEEP TALKIN' HAPPY TALK,
TALK ABOUT THINGS YOU'D LIKE TO DO

IF YOU DON'T TALK HAPPY, DREAM COME TRUE.
THEN YOU'LL NEVER HAVE A DREAM AND YOU'LL NEVER HAVE
HAPPY TALK — SOUTH PACIFIC — Rodgers and Hammerstein

Sean and Mary Kelley
announce the birth of
CAITLIN ANNE
March seventeen, 1990
seven pounds, one ounce

sectur disponere Gdisciplinam jhscle
gis uccognoscere est Gdcluumandm incarne
incellegere naturam quaedhos primum
Requiri dehinc inquaestat quistat uoluimus
agnosci habentes ineraclan excortuaohis
quoniam quiplumtat Gquumrigat uuum
si ut quiuautem increment uur
prefuat ds est incip
ncomchanc euungeu secd
cum lueu lum
uone uute ocheusis urce

## RUNES

Throughout the first millennium, as the Roman Empire expanded into northern Europe, Ireland, and England, and then subsided, the rounded Roman capitals reached a variety of visual compromises with the local Viking runes. These tall, angular hybrids provide dramatic contrast with the plump, coiled Celtic text letters. You can get acquainted with the Runic capitals by deciphering them from old and new calligraphy, using a little Latin, a lot of imagination, and a tolerance for whimsy.

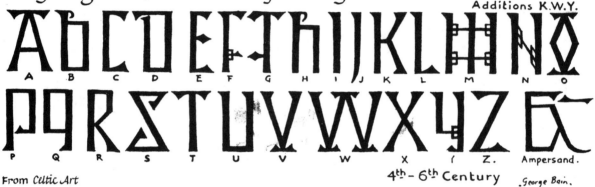

Additions K.W.Y.

A B C D E F G H I J K L M N O
P Q R S T U V W X Y Z. Ampersand.

4th – 6th Century .George Bain.

From *Celtic Art*
by George Bain

You can also make your own runes to fit your design by compressing rounded capitals into rectangles, like pushing hats into shoeboxes; trimming off extra strokes or cramming the extenders in; reinforcing the corners; filling empty areas with dots; and surrounding the letter's structure itself with knots, coils, colors, dots, and interlacings.

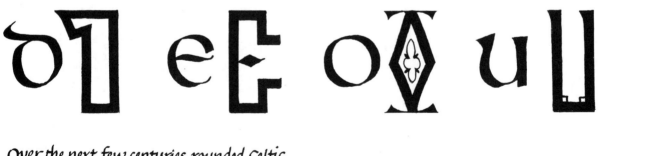

Over the next few centuries, rounded Celtic evolved into pointed Gothic. By the turn of the millennium, the individualistic Celtic letters had been re-costumed into tuxedos and lined up in formal rows.

# gothic

Gothic packs more words into less space than virtually any other alphabetic script style.

othic scribes combined the curves of Roman capitals with the angles of Northern runes. The pointed letters harmonized with the pointed arches and narrow vertical lines of medieval architecture and costume.

Useful as well as artistically expressive, the Gothic alphabet can be squeezed dramatically to fit a lot of text onto a very small piece of parchment.

Gothic survives today for ceremonial use in diplomas, mastheads, awards, and Christmas greeting cards.

## CHOOSE A KIND OF PEN AND A SIZE

Gothic lettering will reward careful practice. The strokes and squares must touch and meet with a geometric precision that helps the reader read and keeps this extremely heavy letter from actually looking heavy on the page. Truly precise joins will be possible only with a sharp pen. Check the pen's sharpness by moving it sideways to make a hairline. If this hairline is thicker than ⅒ the width of the stroke, your pen needs sharpening

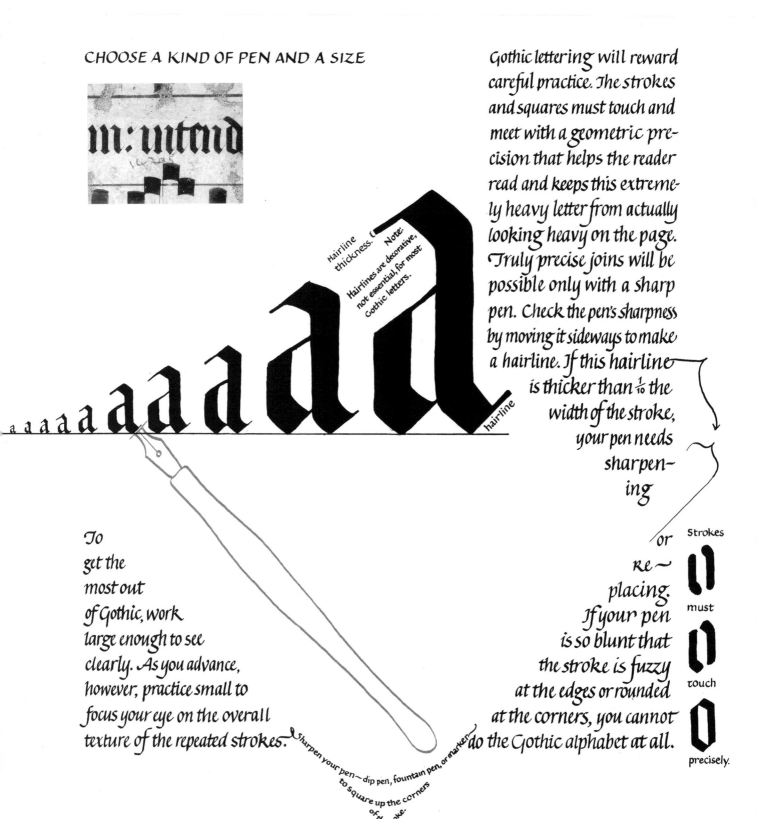

Hairline thickness. Note: Hairlines are decorative, not essential, for most Gothic letters.

hairline

or Re~placing. If your pen is so blunt that the stroke is fuzzy at the edges or rounded at the corners, you cannot do the Gothic alphabet at all.

Strokes must touch precisely.

To get the most out of Gothic, work large enough to see clearly. As you advance, however, practice small to focus your eye on the overall texture of the repeated strokes.

Sharpen your pen~ dip pen, fountain pen, or marker, to square up the corners of the stroke.

## POSITIVE AND NEGATIVE SPACE

To maintain the precision that keeps the Gothic letter beautiful & readable, you must train your eye to see two shapes at once: the six-sided one <u>outside</u> and the four-sided one in-side: the penguin's tuxedo and his shirt. The hex-agonal outline tricks the beginner into trying to write its six sides with six strokes

Now, however, look at the <u>inside</u> shape of the letter, the shape enclosed by the four strokes and squares. According to the generalized Gothic rule, this space will be no wider than the width of the stroke itself. It has only four sides, forming an upright parallelogram. This internal "window" repeats in the centers of a row of Gothic letters like an actual row of windows across the page. Look for this shape, or a part of it, at the heart of most Gothic letters, and build the structure of the letter around it. Use your eye to guide your hand & pen.

The Gothic letter consists of only two squares and two strokes lined up so they touch or meet exactly. The illusion of the fifth and sixth sides is created by the alignment of their flat endings.

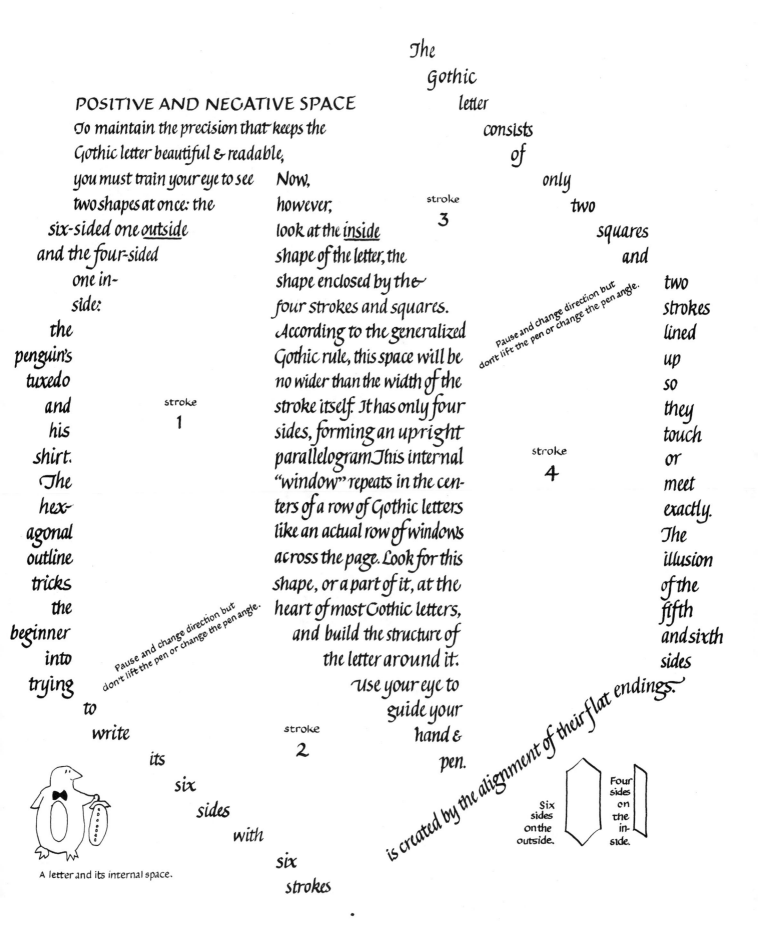

stroke 1

stroke 2

stroke 3

stroke 4

Pause and change direction but don't lift the pen or change the pen angle.

Pause and change direction but don't lift the pen or change the pen angle.

A letter and its internal space.

Six sides on the outside.

Four sides on the in-side.

OPTIONAL EXERCISE

OPTIONAL EXERCISE

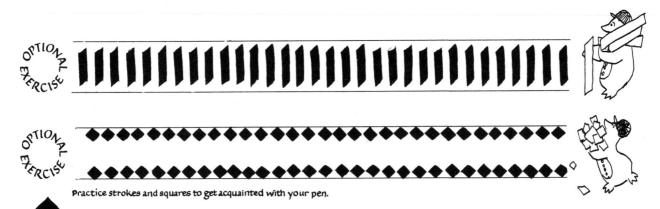

Practice strokes and squares to get acquainted with your pen.

n Gothic, most letters are constructed by lining up straight strokes with squares. These two main parts seem to slide around on a flat plane, like tiles or stained glass, touching at their points or meeting at their flat ends but almost _never overlapping_ Also, almost _no hairlines_ are necessary in Gothic. here are just a few letters that require overlaps or hairlines.

## structure
## structure

straight strokes and squares must be positioned carefully within the guidelines. The point of the square just touches the guideline. The straight stroke never does; instead, it always starts and stops just short of the guidelines so as to leave room for the square. Whether all the squares are needed in the letter or not, a place is kept for them.

## BASIC GOTHIC CONSTRUCTION

Gothic letters are put together with precision from a small kit of interchangeable parts. The exercises here will help you see the letters clearly so as to write them accurately.

A zigzag of the thickest & thinnest strokes helps you position the pen angle correctly.

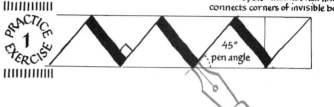

The pen's thinnest hairline connects corners of invisible box.

PRACTICE EXERCISE 1

45° pen angle

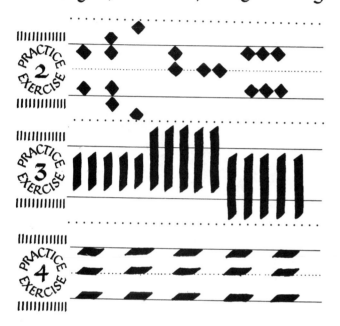

PRACTICE EXERCISE 2

PRACTICE EXERCISE 3

PRACTICE EXERCISE 4

Square strokes balance symmetrically on their points, which should only just touch the guidelines or the points of other squares.

Straight strokes make uniform black and white stripes that stop short of the guidelines.

Flat strokes about 2 nibs long track the guidelines or cross around the middle.

Squares join the top or bottom of the straight strokes. Pause and change the direction of the pen's motion, but do not lift the pen up or rotate it to change the pen angle.

Put squares and strokes together so they just touch and meet without gaps or overlaps, thin lines or curves. Now you have the basic letter body, the model for the others, and the building block of the Gothic page.

PRACTICE EXERCISE 5

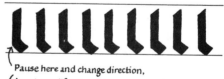

Pause here and change direction, but do not lift pen or change pen angle.

PRACTICE EXERCISE 6

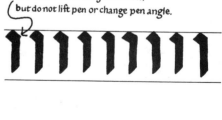

PRACTICE EXERCISE 7

## SPACE IN AND BETWEEN LETTERS

The key to writing and arranging Gothic letters is to visualize them without their top and bottom squares. Viewed in isolation, these vertical strokes should line up like a snow fence or a row of railroad ties.

A line of Gothic lettering follows three simple interrelated rules, which may seem self-evident but are easy for beginners to get wrong. Study the principles illustrated below:

1. Most of the vertical strokes are the <u>same distance</u> apart.

REGULAR VISUAL RHYTHM

EQUAL

2. The spaces <u>inside</u> the letters are as wide as the spaces <u>between</u> the letters.

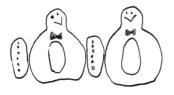

SPACE INSIDE EQUALS SPACE BETWEEN

EQUAL

3. The <u>black strokes</u> are as wide as the <u>white spaces.</u> (In the extremely dense Black Letter style of the Middle Ages, in fact, the black strokes are wider than the white spaces.)

BLACK STROKE EQUALS OR EXCEEDS WHITE SPACE

EQUAL

WIDER/NARROWER

Since Gothic letters bear such a strong family resemblance to each other, you should practice them in categories that will help you pay attention to the small differences between them.

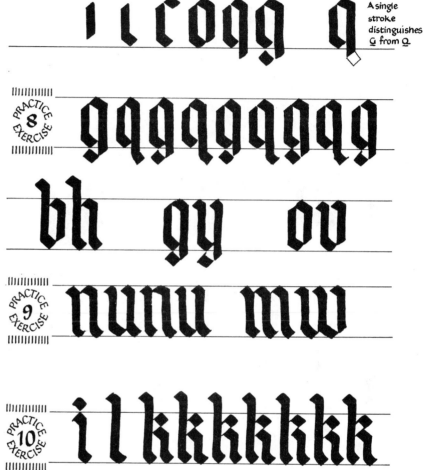

**Closed letters** grow from O by continuing the second downstroke past the lower guideline before ending with a square, or by starting the first stroke over the upper guideline. Neither one sticks out far from the body.

*A single stroke distinguishes G from O.*

PRACTICE EXERCISE 8

**Open letters** often differ from their closed cousins by a single stroke or carefully calibrated join or gap. Practice them in pairs and groups that let you highlight these differences.

PRACTICE EXERCISE 9

**Single width letters** do not enclose space, but do maintain visual kinship using Gothic strokes and joins.

PRACTICE EXERCISE 10

**Exceptions** do their best to express their identity while complying with Gothic structure.

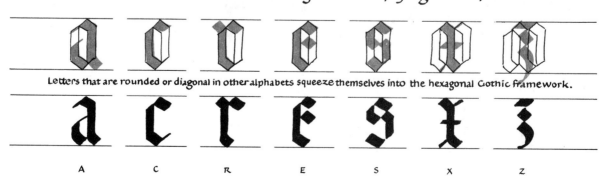

Letters that are rounded or diagonal in other alphabets squeeze themselves into the hexagonal Gothic framework.

A     C     R     E     S     X     Z

GOTHIC

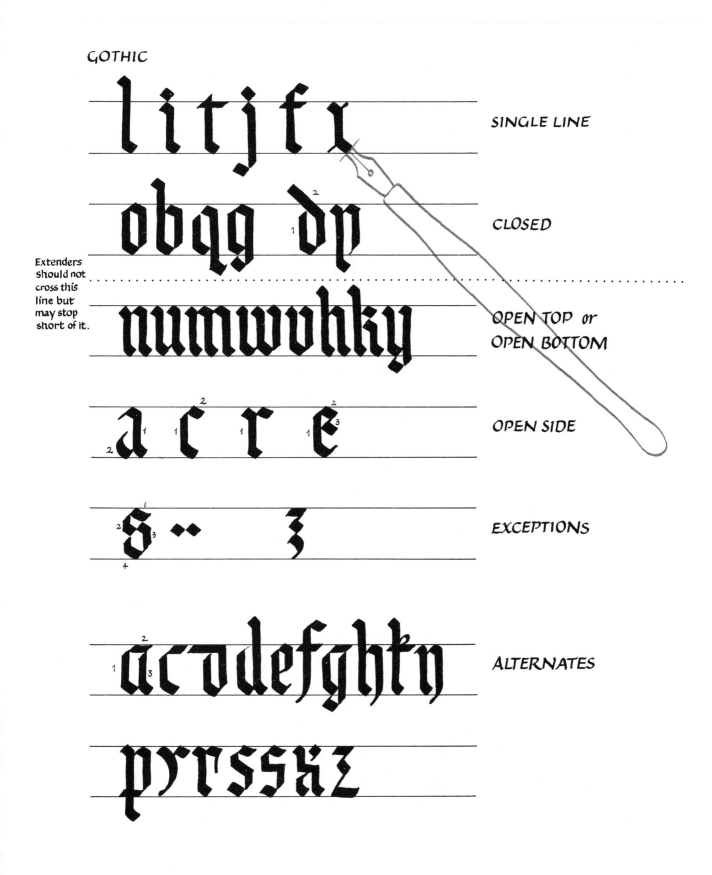

SINGLE LINE

CLOSED

Extenders should not cross this line but may stop short of it.

OPEN TOP *or* OPEN BOTTOM

OPEN SIDE

EXCEPTIONS

ALTERNATES

Use a copier or scanner
to enlarge or reduce the
guidelines to fit the width
of the pen you are using.

## SPACING ON THE PAGE

There are four simple rules to help you with spacing the Gothic <u>letters</u>, <u>words</u>, <u>sentences</u>, and <u>lines</u>.

1. The space between the <u>letters</u> is the width of a pen stroke.

# good among in

Practice repeated uprights in simple letter bodies.

# flock by night

Extenders do not change the the spacing of the letter body.

# same country

Keep exceptions as close to the Gothic framework as you can, to prevent gaps and clumps.

# hallelujah exultate deo

Practice words with a mixture of ◆ standard letters and exceptions.

2. The space between <u>words</u> is the width of a letter body.

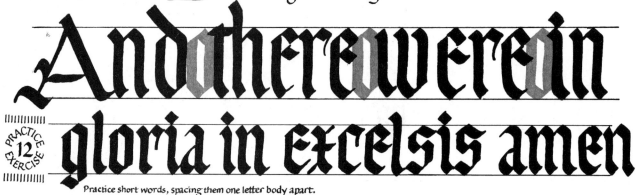

# Andotherewerein

# gloria in excelsis amen

Practice short words, spacing them one letter body apart.

3. *The space between <u>sentences</u> is equivalent to the width of the <u>w</u>.*

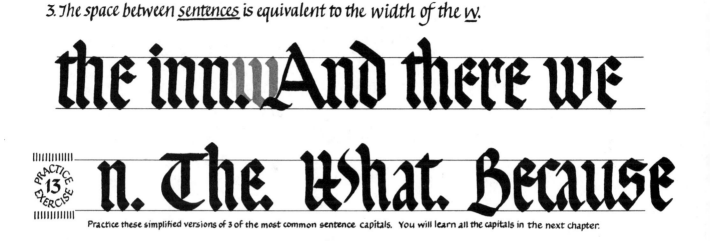

PRACTICE EXERCISE 13

Practice these simplified versions of 3 of the most common sentence capitals. You will learn all the capitals in the next chapter.

4. *The space between <u>lines</u> is the height of one letter body.*

no room for them in the inn. And there were in the same country shepherds abiding in the field, keeping watch over their flock

PRACTICE EXERCISE 14

Keep extenders short to avoid tangles.

by night. And, lo, the angel of the Lord came upon them, and the glory of the Lord shone

*If, however, your text is very short or your letters are very ornate, you may increase the line spacing to help the reader's eye keep moving horizontally along the line of Gothic letters.*

princē heffet op uwe poertē eñ
werdet vheuen ghi ewighe po
poerten eñ het sal in gaen die
coninc der glorien Wie is dele
coninc der glorien die here altre
machten hi is coninc der gloriē
Glorie sij ꝫ Het was Antif
voer deser ioncfrouwen bedde
kyn singhet ons stedelike Zue
te sanghe der minnen vli vor
de gheboert is die gracie in dinē
lipen Daer om heuet di god
ghebenedijt in ewichait. Pr̄ nr̄.
Vader onse. Eñ en in leid ons
niet in becoringhe Mer vlos
vanden quaden Amen v̄ Ouer
mits ghebet eñ v̄dienst der hei
ligher godes moeder eñ maghet

## ARRANGING GOTHIC TEXT ON THE PAGE

There are some traditional ways to arrange a page of Gothic lettering. Keep the texture heavy and the margins straight, not "ragged." To make the lines of lettering come out equal, add strokes of ornamentation, enlarge the capitals, or use creative abbreviations. Don't stretch or squeeze the line length by changing the spaces inside & around the letters. It's better to preserve the same letter spacing from line to line, & even up the right-hand margin inventively.

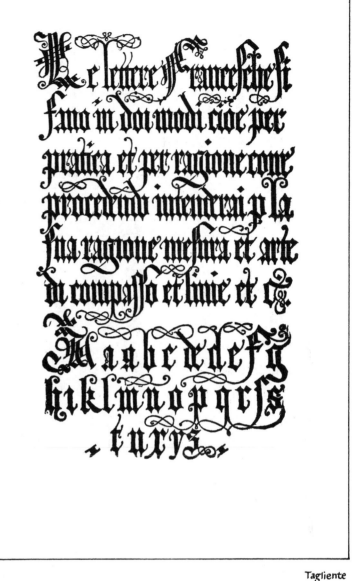

Tagliente

1492 Dutch. Author's collection.
Preceding page: Enlarged detail.

Gutenberg Bible

Gothic letters are a challenge for modern eyes to read. Make it easier by limiting your line length to 35–45 characters. If you need to accommodate a longer text, consider a design that breaks the solid block of text into two slender columns.

# Hanukkah

A Gothic greeting printed white on black can be filled in with several primary colors to look like stained glass.

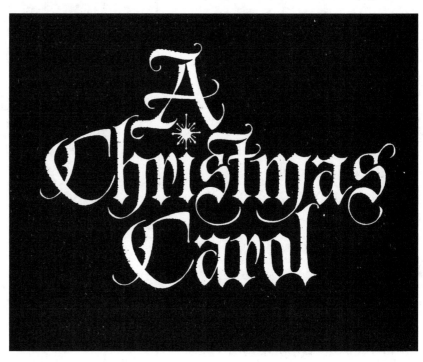

Tom Costello

Although the Gothic letter looks appealing in traditional Gothic layouts, it doesn't have to be stuck in one historical period. Don't use it only for its antiquarian flavor; try it in modern layouts. The scribes of the Middle Ages arranged the page to enhance the Gothic letters' rich density, upward thrust, readability at small sizes, and harmony with the art and architecture around them. Today, you can use the same Gothic letters for similar purposes, in modern designs, if you choose appropriate texts.

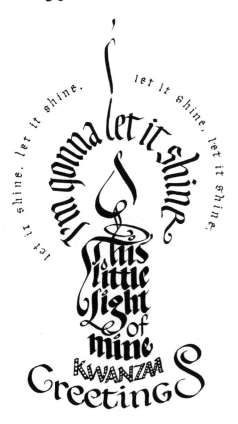

## CHOOSING A TEXT

The Gothic alphabet offers the calligrapher many dramatic strengths and weaknesses. Historically, it speaks in formal, religious tones, which can detract from light, lyrical texts, ironic quotations, or romantic poetry. Put it to use best for formal presentations, ceremonial occasions, logos, religious commentary, and scripture. Its abstract schematic structure also works well with aesthetics and philosophy.

In addition, the role of the Gothic alphabet in the 19th century Gothic Revival all over Northern Europe and England, where many of today's "traditional" Christmas customs originated, makes it a nearly inevitable choice for holiday greetings.

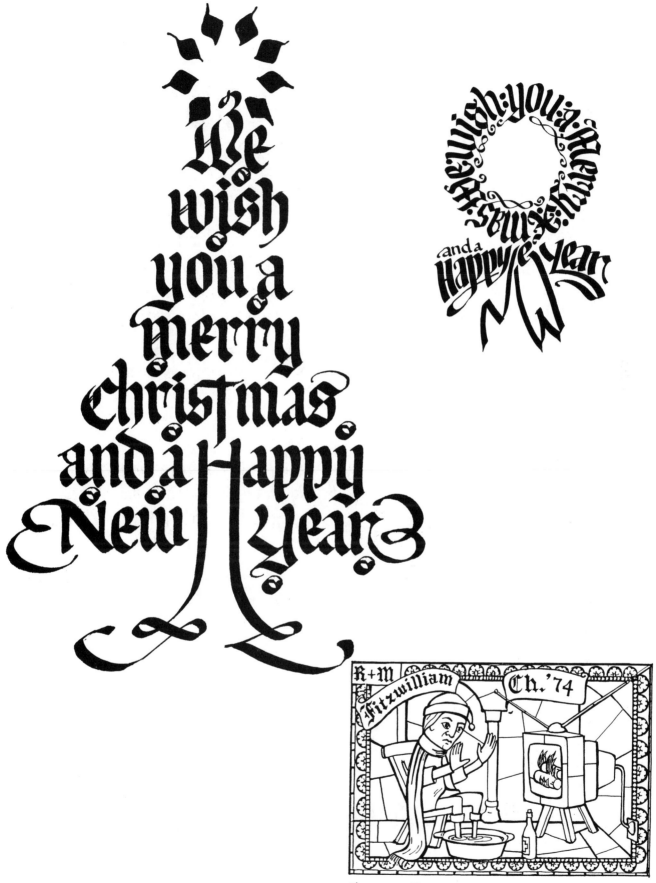

We wish you a merry christmas and a Happy New Year

We wish you a Merry Christmas and a Happy New Year

R+M Fitzwilliam Ch. '74

Margaret Fitzwilliam

## VARIATIONS ON THE BASIC GOTHIC RULES

Now that you have disciplined yourself to write Gothic letters according to the rules — precise, dense, angular, uniform — you can tinker with the rules. Some of these variations will change the alphabet as a team.

### LETTER ANGLE

The letters don't have to stand exactly upright. They can <u>lean</u> a few degrees without losing their Gothic look, if they all lean together (and don't lean too far!).

### DENSITY

Originally useful because they could be so tightly packed, a crowd of Gothic letters can <u>spread</u> themselves a little farther apart. They can then each take up a little more space.

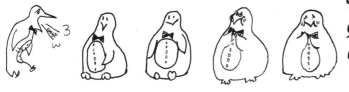

### ANGULARITY

The Gothic hexagon can appear to <u>cave in</u> or <u>bulge out</u>, like a container being either deflated or pumped up.

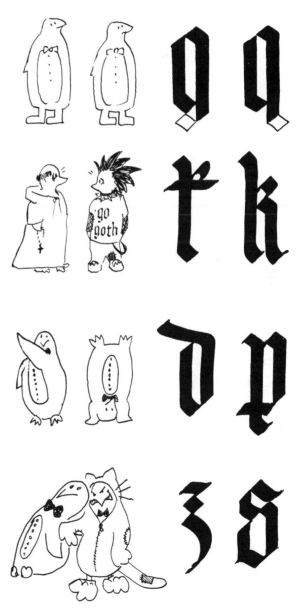

The letters of the Gothic alphabet, however, do not always change in unison. Like any clan, alphabets are made up of individuals whose loyalty to the clan must always be balanced with their need to express their uniqueness. Gothic is visually complex enough to accommodate many individual quirks as long as the underlying family relationships are not disrupted.

Some pairs of letters look so much like each other that they may be mistaken for each other unless you accentuate the few small features there are that do <u>distinguish</u> between them.

Some letters in use today were not in the Gothic alphabet, or were familiar then in forms that seem strange to us. You can <u>modernize</u> them for today's readers without losing the Gothic look.

Some letters contain <u>awkward areas</u> that will work better with non-standard strokes & joins. Usually the upside-down version of such a letter needs to have the same visual problem solved.

<u>Z</u>, <u>s</u>, and <u>x</u>, among others, are just <u>hard</u> to fit into the Gothic family. Use the forms that Gothic scribes devised to accommodate them, or you can try your own adaptations.

Gothic letters as a crowd can dress up their sober black suits many ways for special occasions, adding ornament to their bodies and limbs in a variety of old and new styles.

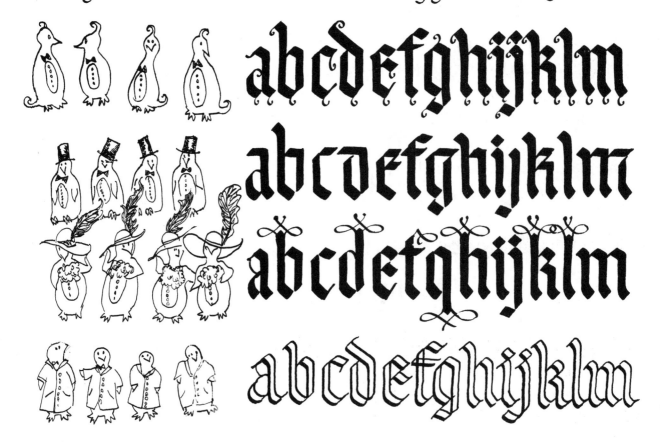

abcdefghijklm

abcdefghijklm

abcdefghijklm

abcdefghijklm

**BEYOND GOTHIC**   Emerging from the tightly packed rows of Gothic text, a few initial letters grew larger and dressed up in decorated costumes. These eye-catchers, each one unique, evolved into the star performers of the densely populated medieval page.

ooooooooo

oooooooooo

oooooooooo

ooooooooooooo

ooooooooooooo

oooooooooooooooo

ooooooooooooooo

ooooooo

ooooooo

ooooooo

ooooooooooooooooooo

ooooooooooooooooooo

ooooooooooooooooooo

ooooooooooooooooooooo

Pen **Gothic** Drawn **Capitals**
Capital • Capital

# APITALS IN THE MIDDLE AGES

decorated the pages of most Gothic texts with a splash of color and gold. Whether written in just a few quick pen strokes by the monastic scribe, or drawn and filled in elaborately by a team of illuminators and gilders, a capital played an important role. It stood out from the block of regimented black text to emphasize a chapter break, tell a story for non-readers, portray the author of the scripture or the patron of the manuscript, frame a landscape, illustrate a catalog, or just add an extra layer of visual richness

## CHOOSE A KIND OF PEN AND A SIZE

*Write the pen-lettered capitals with the same pen you have been using for the Gothic text. A Gothic letter 5 nibs high looks best with a capital just 1 or 2 nibs taller; the extra width, distinctive doubling of strokes, and added decoration give the capital all the emphasis it needs. Don't let Gothic capitals get spindly or tower over the text letters.*

Gothic capitals this size
and larger are usually
outlined and filled in.

Too tall →

Capitals   Capitals   Capitals   Capitals

Capitals do not have to be much taller than the text letter body itself.

*Start adding small, simple capitals to your Gothic texts without changing the pen size, the pen angle, the ink color, the guidelines, or the margins — later you can experiment with more variations.*

*Review the basic Gothic pen strokes (page 67), plus a few simple geometric curves.*

OPTIONAL EXERCISE

Basic Gothic pen strokes.          Additional geometric curves.

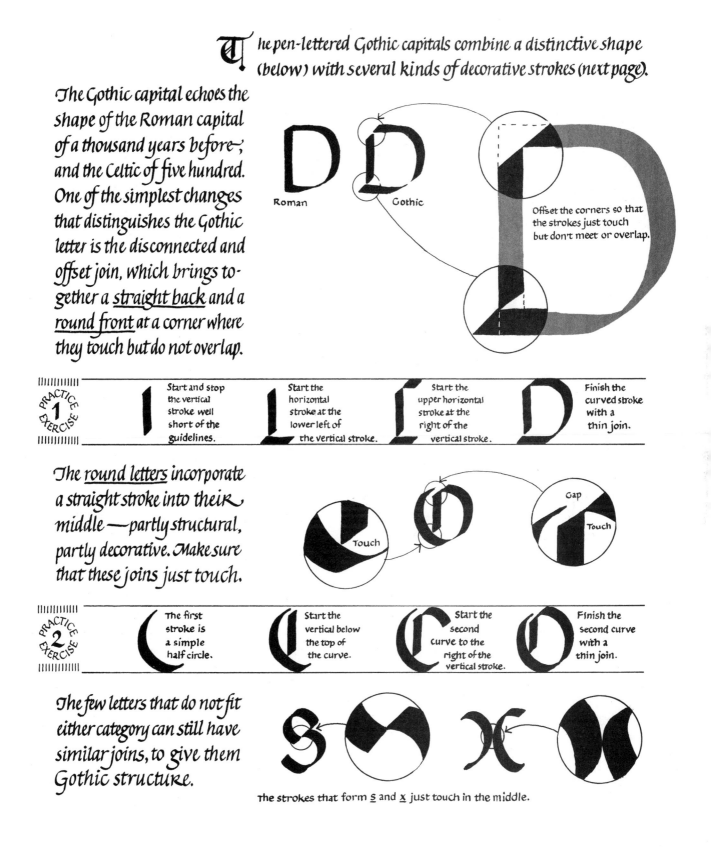

*The pen-lettered Gothic capitals combine a distinctive shape (below) with several kinds of decorative strokes (next page).*

*The Gothic capital echoes the shape of the Roman capital of a thousand years before; and the Celtic of five hundred. One of the simplest changes that distinguishes the Gothic letter is the disconnected and offset join, which brings together a <u>straight back</u> and a <u>round front</u> at a corner where they touch but do not overlap.*

Roman        Gothic

Offset the corners so that the strokes just touch but don't meet or overlap.

**PRACTICE EXERCISE 1**

Start and stop the vertical stroke well short of the guidelines.

Start the horizontal stroke at the lower left of the vertical stroke.

Start the upper horizontal stroke at the right of the vertical stroke.

Finish the curved stroke with a thin join.

*The <u>round letters</u> incorporate a straight stroke into their middle — partly structural, partly decorative. Make sure that these joins just touch.*

Touch

Gap        Touch

**PRACTICE EXERCISE 2**

The first stroke is a simple half circle.

Start the vertical below the top of the curve.

Start the second curve to the right of the vertical stroke.

Finish the second curve with a thin join.

*The few letters that do not fit either category can still have similar joins, to give them Gothic structure.*

The strokes that form <u>s</u> and <u>x</u> just touch in the middle.

## PEN CAPITALS WITH ORNAMENT

While simple pen-lettered capitals look Gothic enough to blend with a page of text, you can indulge in a rich selection of ornamental pen strokes to dress them up more. Though it may look like each individual letter is unique, in fact the ornamental strokes follow some simple visual rules. Practice the five kinds of strokes shown here, studying where they are positioned in the two main Gothic letter structures.

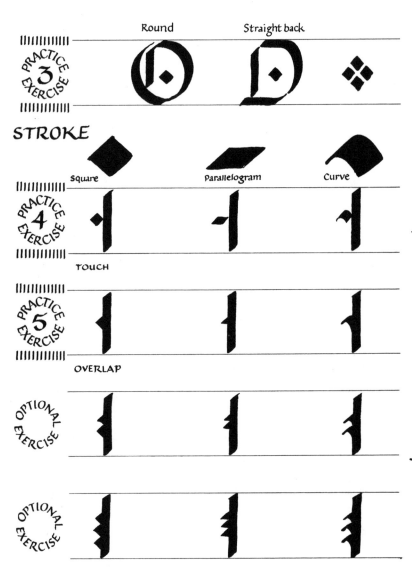

The simplest square can dress up many capitals. _Float_ one in the middle of a round space. Float a cluster in a big space!

The same square, rendered as a parallelogram or curve, can just _touch_ the outside edge of a vertical letter stroke.

With a little extra care, you can _overlap_ the short stroke on the straight letter stroke.

Try the effect of one, two, or three repeated strokes. Aim for precision to give elegance. (If you use transparent ink or marker, you will be able to see the overlaps clearly so as to line up the strokes accurately.)

Gothic capitals frequently in-clude a vertical stroke, which can be <u>doubled</u> to give extra visual buzz.

DOUBLED

Doubled vertical strokes can be <u>tied</u> together with hairlines made with a short side-to-side pen motion.

TIED

Make longer <u>hairlines</u>, with the pen at any angle, to triple the vertical stroke or close up an open letter.

HAIR-LINE

Some pens allow you to <u>drag</u> along a thin ink line out of the main stroke using just the corner of the nib.

DRAGGED

Use one corner of the nib to pull out ink from main stroke while it is still wet.

A <u>banner</u> can attach onto a vertical hairline or float in the air:

BANNER

## GOTHIC PEN CAPITALS

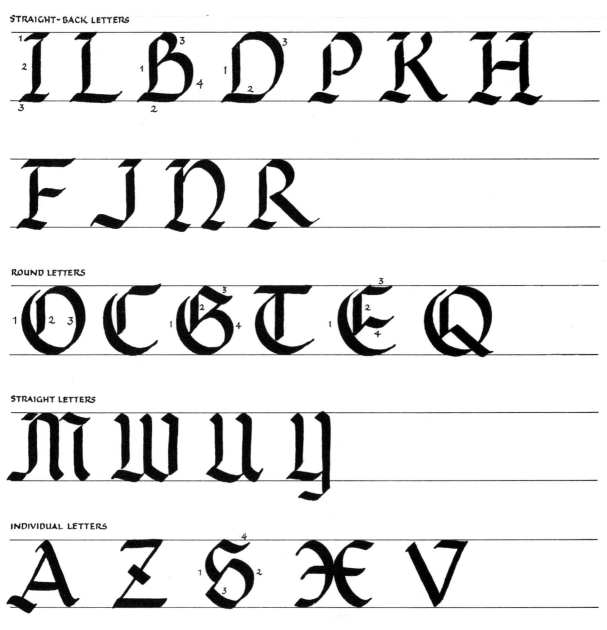

**STRAIGHT-BACK LETTERS**

**ROUND LETTERS**

**STRAIGHT LETTERS**

**INDIVIDUAL LETTERS**

*Add strokes to achieve the level of ornament you want. In general, assemble the letter from left to right, from inside out, from thick to thin, from structural to optional.*

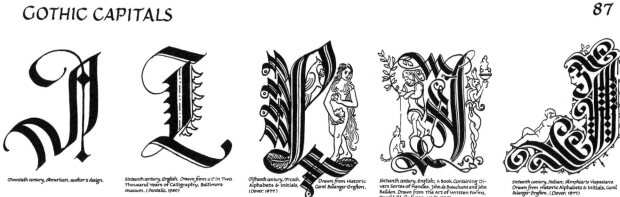

*Twentieth century, American, author's design.*

*Sixteenth century, English. Drawn from a J in Two Thousand Years of Calligraphy, Baltimore Museum. (Dentelle, 1980)*

*Fifteenth century, French. Drawn from Historic Alphabets & Initials, Carol Belanger Grafton. (Dover, 1977)*

*Sixteenth century, English; A Book Containing Divers Sortes of Handes. John de Beauchesne and John Baildon. Drawn from The Art of Written Forms, Donald M. Anderson. (Holt, 1968)*

*Sixteenth century, Italian; Amphiario Vespasiano. Drawn from Historic Alphabets & Initials, Carol Belanger Grafton. (Dover, 1977)*

German capitals, 1529

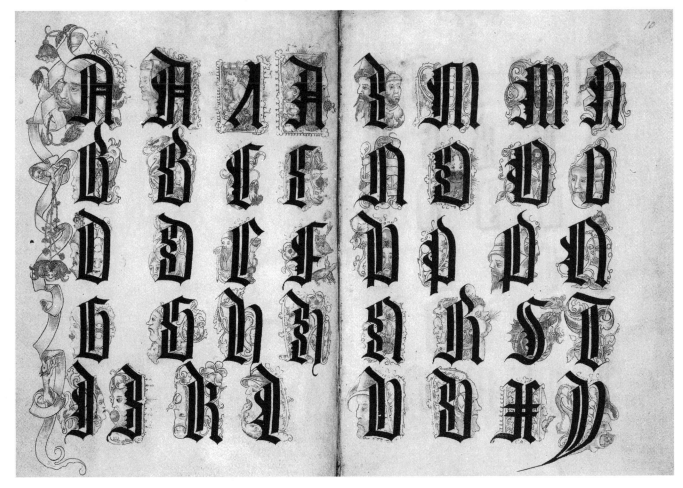

## CHOOSE A PEN AND A BRUSH

Huge or tiny, drawn capitals are outlined with a thin brush or a narrower pen than what you were writing the text with. In the Middle Ages the capitals were added later, not just with a different pen but by a different person, who specialized in the materials and techniques of illumination. Without getting sidetracked too far from calligraphy yourself, you can learn just enough to design drawn capitals into your Gothic pages.

Until you are experienced at drawing the capitals, you should sketch them first on a separate sheet of paper, then transfer them or copy them by eye into the space you have provided in your design.

OUTLINE     INFILL

Medium brush

Thin brush

Crowquill or mapping pen

Narrow calligraphy pen

Choose nib width that is physically easy to handle, and visually helps you and your readers to see the outlined stroke shape.

Too heavy

Thinner and thinner pen for smaller and smaller letters

The exact width of the pen, in relation to the height of the letter or the width of the stroke, is not so crucial here as in other alphabets. A nib about $\frac{1}{12}$ the width of the drawn stroke is thin enough to focus your eye on the shape inside the outline instead of the pen stroke.

## CHOOSE OUTLINE INK

Outline the letter with water-proof ink, which will not run when you fill it in. Although you can mimic the look of stained glass with a heavy black outline, it deadens the color and in fact makes the letter harder to read. And, a pale outline ink is easier to cover up with color.

Depending on your pen, outline the letter with a diluted gray tint of your practice ink, or change to sepia (brown) or ochre (tan). Some artists find a useful pale neutral beige in the wash water pot they have rinsed a lot of brushes in.

Ed Karr

## CHOOSE INFILL PAINT

A medieval scribe's color choice was defined by what pigment was available as well as what color was customary. Red was traditionally used in the Bible to letter the spoken word of God, and in a Book of Hours for the calendar of saints' days (thus a "red letter day" came to mean a special day in a person's religious year). Illuminators learned that they could rely on red and blue paints not to fade or change color from exposure to light or chemical interaction with each other.

Calligraphers today sometimes try to make their designs look "olde" with faded brown ink, yellowed paper, and torn or scorched edges. This fake look is entertaining but inaccurate, as medieval scribes aimed for dense black ink on flawless pure white parchment.

Black outline overwhelms most colors. Neutral outline does not detract from colors.

Fill the outline...or cover it.

Gold paint brushes on with a powdery matte surface... ...that can be burnished to a little more shine.

Gold appears on medieval pages in two forms: as gold powder in thin transparent liquid that is brushed or dotted on, or as thin sheets laid on top of slightly sticky letter shapes and burnished smooth to look like solid gold. Study old techniques, or improvise with modern materials.

A base coat of sticky gesso is painted on first; gold leaf adheres to it... ...and is burnished to a brilliantly shiny surface.

## D + R + A + W = N

| ROMAN | CELTIC | RUNIC | GOTHIC | DRAWN |

Drawn Gothic capitals pull together letter forms from classical Roman, Celtic, Runic, and pen Gothic capitals. Medieval scribes did not just copy these styles in outline, however, but created a special letter that is distinctive for its simplicity, symmetry, and framed interior space.

### SIMPLE CAPITAL BALANCES BUSY TEXT

Reduced to the size of a bug, surrounded by a web of ornament, embedded in a dense thicket of text, a drawn capital letter still stands out clearly on the page. Its simplicity is based on its proportions, contours, color field, writing speed, and group identity.

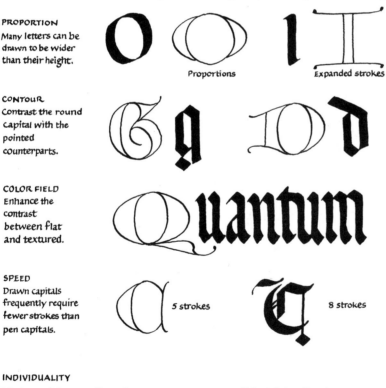

**PROPORTION**
Many letters can be drawn to be wider than their height.

Proportions     Expanded strokes

**CONTOUR**
Contrast the round capital with the pointed counterparts.

**COLOR FIELD**
Enhance the contrast between flat and textured.

Quantum

**SPEED**
Drawn capitals frequently require fewer strokes than pen capitals.

5 strokes     8 strokes

**INDIVIDUALITY**
Whole words in pen capitals look uneven and are difficult to read.     Drawn capitals work together visually and are easier to read.

Wide proportions let the capital contrast with the narrow text letter. A wide letter looks big without needing to be tall.

Rounded contours distinguish the smooth capital from the prickly text letter.

Flat color field is different from the fine grain of the text & the delicate mesh of the ornament. A simple letter is quick to write. A simple letter can submerge its individuality into a group identity, allowing the scribe to write whole words using drawn capitals. Unlike the pen-lettered prima donnas, they can work together in harmony.

TWO KINDS OF SYMMETRY
The drawn capital is character-
ized by stroke symmetry, with
each half of the outlined stroke
a mirror image of the other.
The vertical strokes are balanced
along an imagined or penciled
center line, spreading slightly at
top and bottom. A few strokes
are symmetrical horizontally.

Pencil center line

Erase pencil line

STROKE SYMMETRY

In addition, drawn capitals have the quality of
letter symmetry, their two halves balanced in
mirror image of each other. As with strokes,
letters can be symmetrical along a vertical or
horizontal axis, or both. Look for near-
symmetries and enhance them as well.

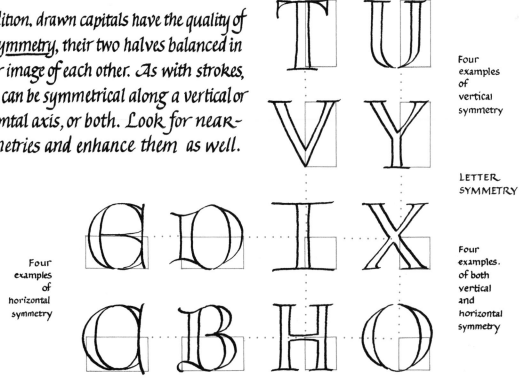

Four
examples
of
vertical
symmetry

LETTER
SYMMETRY

Four
examples
of
horizontal
symmetry

Four
examples.
of both
vertical
and
horizontal
symmetry

The brain is good at mirror images. Build up the
symmetrical letters in balanced pairs of out-
line strokes to let your eye guide your hand.
Work from left to right, from inside to outside.

THE VOCABULARY
OF ORNAMENT

| Rubricated (red) | Textured (with repeating elements) | Foliated (with leaves and flowers) | Inhabited (with people and animals) | Historiated (with an event or a story) | Gilded and filigreed (with gold paint or gold leaf) |

TC

## AT LEAST SIX WAYS TO DECORATE A CAPITAL

The major virtue of the simple, symmetrical letter is that it invites decoration. Without demanding the repetitive labor of a decorated border, the space in, around, and within the letter can give the beginning scribe a chance for artistic expression.

Because sentences in English so often start with "The," extra T capitals are given here and on page 94.

Start simple.

Stay close in.

Don't let ornament sprawl.

Too much ornament swamps the letter.

Emphasize the letter's function as a frame by writing the inside strokes first. The outside strokes are secondary.

Sometimes you can't have it all—decoration outside, inside, and within the letter may be just too much. Less ornament may in fact have more visual impact.

## THREE MAJOR KINDS OF FRAMED LETTER SPACE

OUTSIDE

Start with the area immediately *outside* the letter. Keep this ornament snug inside a real or imagined box, unless the letter's position at the edge of the text lets it extend into the margin.

INSIDE

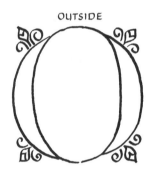

Most drawn capitals can be configured to frame a round window. The decoration you put *inside* does not have to match what is in the corners.

WITHIN

Decoration *within* the letter stroke itself must contrast with what is inside and outside. Too much similarity of color, scale, motif, and tone will just confuse the eye and camouflage the shape.

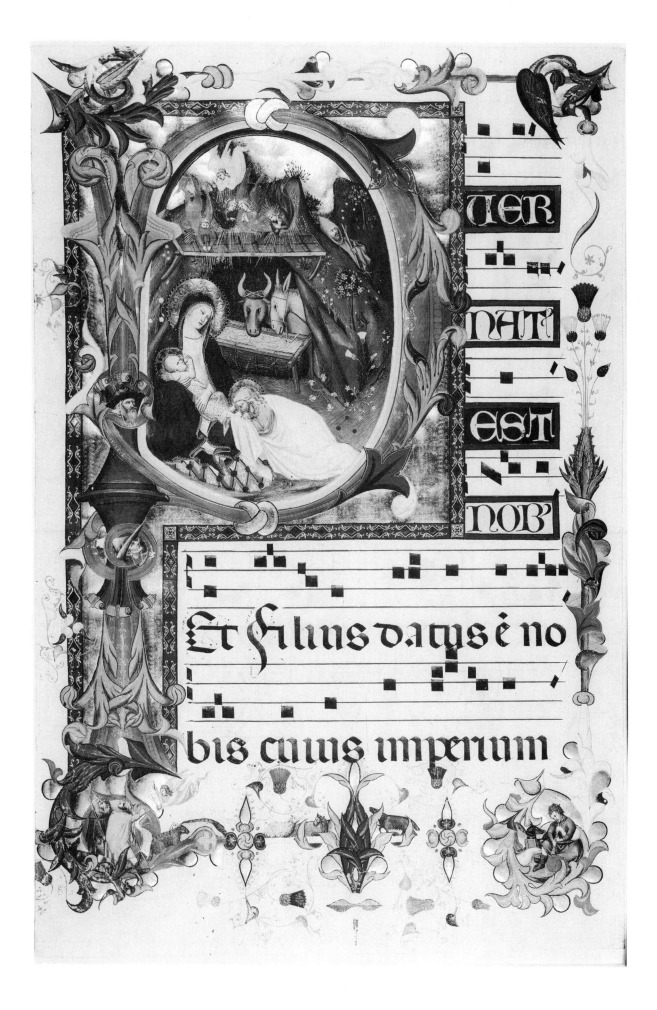

## GOTHIC DRAWN CAPITALS

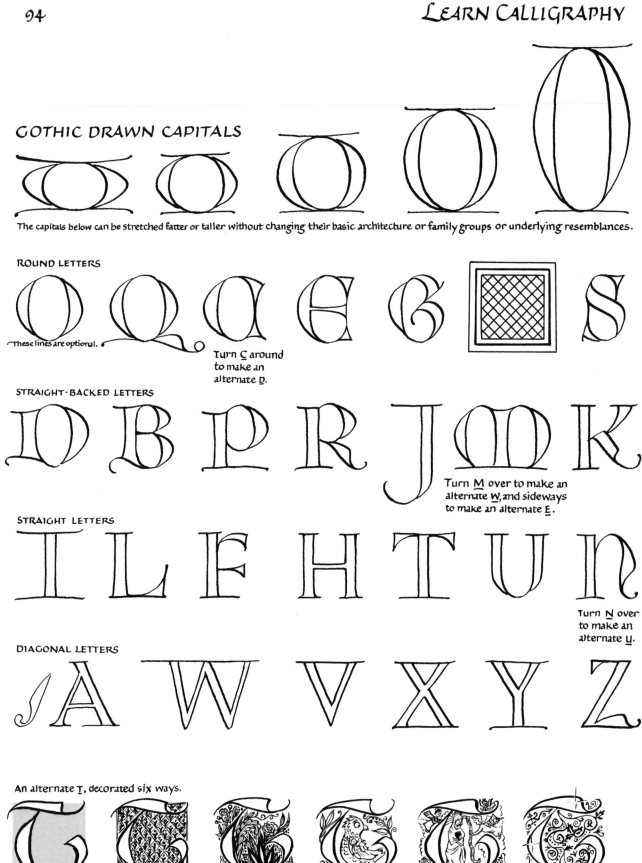

The capitals below can be stretched fatter or taller without changing their basic architecture or family groups or underlying resemblances.

### ROUND LETTERS

These lines are optional.

Turn C around to make an alternate D.

### STRAIGHT-BACKED LETTERS

Turn M over to make an alternate W, and sideways to make an alternate E.

### STRAIGHT LETTERS

Turn N over to make an alternate U.

### DIAGONAL LETTERS

An alternate T, decorated six ways.

MH

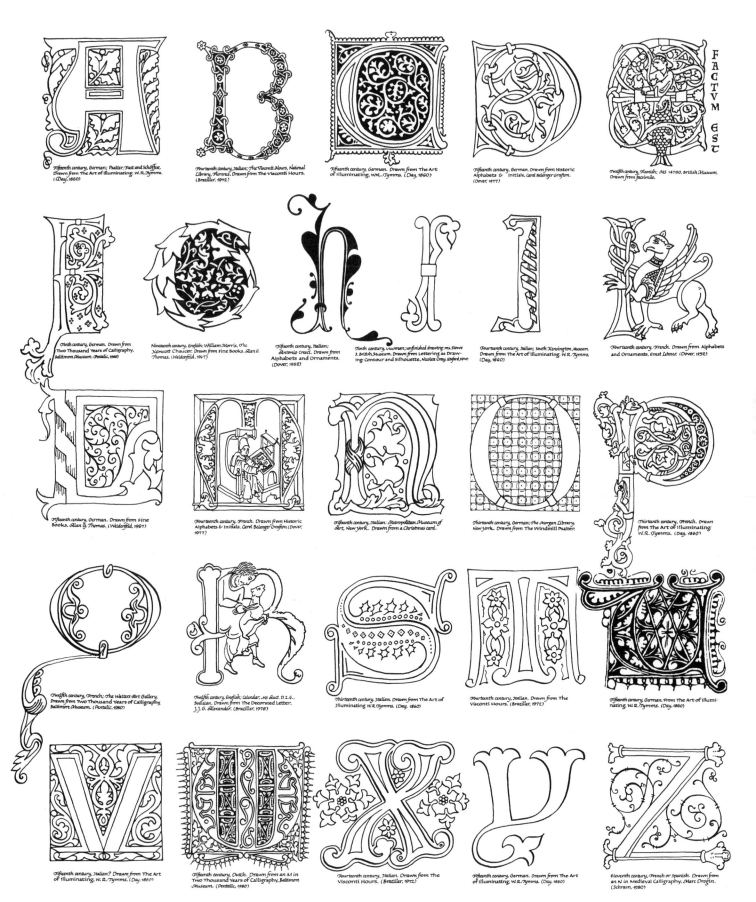

Fifteenth century, German; Psalter, Fust and Schöffer. Drawn from The Art of Illuminating. W.R. Tymms. (Day, 1860)

Fourteenth century, Italian; The Visconti Hours, National Library, Florence. Drawn from The Visconti Hours. (Braziller, 1972)

Fifteenth century, German. Drawn from The Art of Illuminating. W.R.. Tymms. (Day, 1860)

Fifteenth century, German. Drawn from Historic Alphabets & Initials. Carol Belanger Grafton. (Dover, 1977)

Twelfth century, Flemish; MS 14790, British Museum. Drawn from facsimile.

Ninth century, German. Drawn from Two Thousand Years of Calligraphy. Baltimore Museum. (Pentalic, 1980)

Nineteenth century, English; William Morris, The Kelmscott Chaucer. Drawn from Fine Books. Alan G. Thomas. (Weidenfeld, 1967)

Fifteenth century, Italian; Antonio Cresci. Drawn from Alphabets and Ornaments. (Dover, 1982)

Tenth century, unknown; unfinished drawing. ms. Stowe 3, British Museum. Drawn from Lettering as Drawing; Contour and Silhouette. Nicolete Gray. (Oxford, 1970)

Fourteenth century, Italian; South Kensington Museum. Drawn from The Art of Illuminating. W.R. Tymms. (Day, 1860)

Fourteenth century, French. Drawn from Alphabets and Ornaments. Ernst Lehner. (Dover, 1952)

Fifteenth century, German. Drawn from Fine Books. Alan G. Thomas. (Weidenfeld, 1967)

Fourteenth century, French. Drawn from Historic Alphabets & Initials. Carol Belanger Grafton. (Dover, 1977)

Fifteenth century, Italian; Metropolitan Museum of Art, New York. Drawn from a Christmas card.

Thirteenth century, German; The Morgan Library, New York. Drawn from The Windmill Psalter.

Thirteenth century, French. Drawn from The Art of Illuminating. W.R. Tymms. (Day, 1860)

Twelfth century, French; The Walters Art Gallery. Drawn from Two Thousand Years of Calligraphy. Baltimore Museum. (Pentalic, 1980)

Twelfth century, English; Calendar, MS Auct. D.2.6., Bodleian. Drawn from The Decorated Letter. J.J.G. Alexander. (Braziller, 1978)

Thirteenth century, Italian. Drawn from The Art of Illuminating. W.R. Tymms. (Day, 1860)

Fourteenth century, Italian. Drawn from The Visconti Hours. (Braziller, 1972)

Fifteenth century, German. From The Art of Illuminating. W.R. Tymms. (Day, 1860)

Fifteenth century, Italian? Drawn from The Art of Illuminating. W.R. Tymms. (Day, 1860)

Fifteenth century, Dutch. Drawn from an M in Two Thousand Years of Calligraphy. Baltimore Museum. (Pentalic, 1980)

Fourteenth century, Italian. Drawn from The Visconti Hours. (Braziller, 1972)

Fifteenth century, German. Drawn from The Art of Illuminating. W.R. Tymms. (Day, 1860)

Eleventh century, French or Spanish. Drawn from an N in Medieval Calligraphy. Marc Drogin. (Schram, 1980)

A selection from *Capitals for Calligraphy*, Margaret Shepherd

## ARRANGING PEN CAPITALS AND DRAWN CAPITALS ON THE GOTHIC PAGE

# SHOW-OFFS

# TEAM PLAYERS

Pen capitals should _not_ be written together in words. Each of them likes to show off, alone, in the spotlight, so keep them out of each other's way. Use them one at a time.

Drawn capitals _may_ be written into words; but they lose their visual impact if over-used. They are good team players if given uniforms and common goal.

Capitals embedded in Gothic text must fit between Gothic guidelines. Keep them at Gothic height, while you vary the width, ornament, and color to emphasize some letters. The viewer will both read and see.

Capitals by Tom Costello

Both kinds of capitals can be embedded in blocks of Gothic text if they stay inside the same guidelines. Vary the letters' width, color, and ornament to emphasize some letters over others. Write the pen capitals as you go; estimate (or measure) space to add in the drawn capitals later. Add black ornamental strokes now and thin red or tan filigree later to pen capitals; drawn capitals should be filled with red, blue, or gold & filigreed in red or tan.

You can let a drawn capital that occurs at the left margin grow taller than a line of text. Try starting a paragraph with a simple capital two lines high and about as wide.

Write the text first, leaving space to fill in the capital later.

T oooooooooooooo
  oooooooooooooo
oooooooooooooooooo
oooooooooooooooooo
oooooooooooooooooo
oooooooooooooooooo

FULL CUT

O ooooooooooo
  ooooooooooo
  ooooooooooo
oooooooooooooooo
oooooooooooooooo

HALF CUT

P ooooooooooooo
  ooooooooooooo
  ooooooooooooo
ooooooooooooooooo
ooooooooooooooooo
ooooooooooooooooo
ooooooooooooooooo

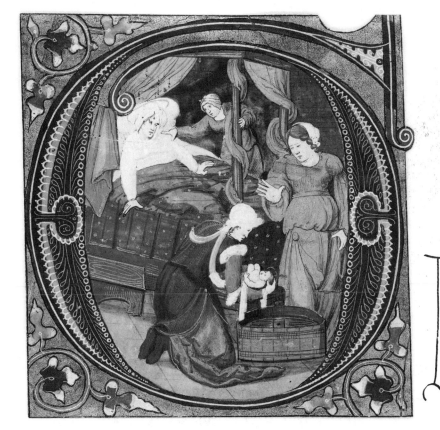

1530 French. *Birth of the Virgin Mary.* Author's collection.

Most drawn capitals will fit snugly in a square space; a few will cut halfway into the corner of the text and also extend into the margin; *I* and *J* can occupy the margin without cutting into the text.

NO CUT

I oooooooooooooooooooo
  oooooooooooooooooooo
  oooooooooooooooooooo
  oooooooooooooooooooo
  oooooooooooooooooooo
  oooooooooooooooooooo
  oooooooooooooooooooo

PLACING CAPITALS ON THE PAGE—A.D. 1200

begin to dominate the page, crowding out the letters with elaborate and exquisite miniature painting...

PLACING CAPITALS ON THE PAGE — A.D. 1450

With the invention of moveable type, Capitals become a separate element on the page—both visually and technically. Usually, the typesetter is duty-bound to put them in just where they occur; cannot stretch or squeeze a line in the scribe's natural manner. The layout of the page is somewhat outside the typesetter's control by now. Technically, capitals straddle the divide between the handlettered book & the printed book in a number of ways. Using a small letter as a cue, a skilled illuminator can then fill the space with a hand-painted decorated capital. Or, more likely, the capital can be pen-lettered with a few strokes. Another kind of approach, a woodcut capital, harmonizes with the heavy texture of the smaller text letters. A woodcut in two colors is delicate enough to provide contrast with the text letters, and let light into the page. The design of a two-column traditional page, with the capitals dotted about on the left margins, can be mastered by a calligrapher with a repertoire of strong, square, decorative but unspectacular and interchangeable initials.

PLACING CAPITALS ON THE PAGE—A.D. 1500

WITH BOOKHAND, WE SEE A CLEAR, THREE-LEVELED stratification of capital design & use. First, the lower-case Roman style has its own capitals for use in the text area. Second, larger Roman capitals are used in headings without any smaller letters. Third, a decorated (but not so decorated as formerly) initial dominates the page. The overall effect is light, yet rich and varied to the eye...

From *Capitals for Calligraphy*

### BEYOND GOTHIC

The ideas of the Renaissance and the technology of the printing press combined in the 15th century to replace Gothic with a new kind of letter. Typographer and calligrapher, painter and sculptor, poet and architect, all were seeking to reinvigorate their art with fresh French and Italian forms. The book page, and the ideas spelled out there, took on new clarity.

Gothic capitals, once encrusted with ornament, were reduced to one or two colors for printing, and then further streamlined as scribes revived classical Roman capitals. Margins emerged clear of ornament. And the very texture of the page softened as Gothic's interchangeable letter bodies, sharp corners, mechanical joins, rigid spacing, and heavy serifs evolved into Bookhand's rounded letter bodies, arched corners, elegant joins, and graceful serifs.

# bookhand

ookhand flowered at the end of the Middle Ages, but its roots reach back almost to classical Rome. Charlemagne's scribes in 800 used 4ᵗʰ century Roman alphabets to copy classical and religious texts in the minor rebirth of learning that characterized his reign. Crowning himself Holy Roman Emperor, he decreed a "Roman" letter to give his written words the legitimacy of an earlier, purer regime.

Scribes of the Italian Renaissance, in turn, revived Carolingian minuscule in their search for a text letter to go with Roman capitals, renaming it "Humanistica." Standardized by typographers as "lower-case Roman" and rediscovered by Victorian craftsmen as "Foundational," Bookhand calligraphy is the source of the everyday text letter for most of today's world.

CHAPTER V.

T HAVE often noticed that almost every one has his own individual small economies—careful habits of saving fractions of pennies in some one peculiar direction—any disturbance of which annoys him more than spending shillings or pounds on some real extravagance. An old gentleman of my acquaintance, who took the intelligence of the failure of a Joint-Stock Bank, in which some of his money was invested, with stoical mildness, worried his family all through a long summer's day, because one of them had torn (instead of cutting) out the written leaves of his now useless bank-book ; of course the corresponding pages at the other end came out as well, and this little unnecessary waste of paper (his private economy)

ABCDEF
GHIKLMN
OPQRSTV
XYYZZ

Giamai tarde non
fur gratie diuine,
In quelle spero, che
in me ancor faráno
Alte operationi, e
pellegrine .

ecutive secretary.

"I honestly feel Mike did not foul me intentionally," Norris said in a statement.

The punch was also deemed accidental by referee Richard Steele.

"Because it was accidental it was ruled a no contest because it went less than four rounds," Ratner said.

Tyson was disqualified for biting Evander Holyfield's ears in the third round in the same MGM Grand Garden ring June 28, 1997. His license was revoked for 15 months.

Bookhand, from 1522 to 2002

## CHOOSING A KIND OF PEN AND A SIZE

*Since the invention of printing, Bookhand has made itself familiar to 20 generations of readers as the typeface of choice in printed books, newspapers, mail, magazines, and digital screens. It does not require large size to instruct the beginner, or to appeal to the critic, or to be legible to the average reader. The beauty of Bookhand is most accessible at medium size.*

h h h h h height h

20° pen angle

If you write Bookhand at very small size (or even if you reduce to small size something written large), a curious thing happens: the reader stops appreciating its beauty as handlettered calligraphy and starts comparing its flaws to the perfections of type.

Handlettering

If you write Bookhand at a very small size (or even if you reduce to small size something written large), a curious thing happens: the reader stops appreciating its beauty as handlettered calligraphy and starts comparing its flaws to the perfections of type.

Type

*Choose a size large enough to highlight the proportions and joins that give this style its distinction, but still small enough to let you appreciate the abstract overall texture that the letters build up on the page, and to fit comfortably with your hand & pen.*

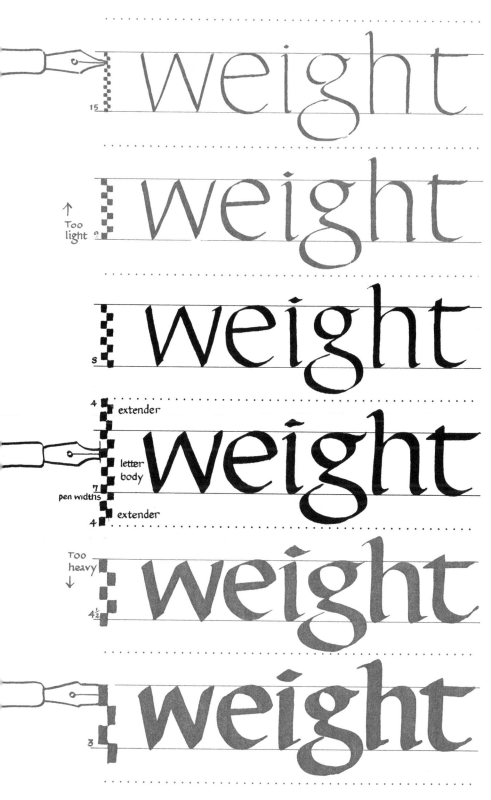

weight

weight — Too light

weight

extender
letter body
7 pen widths
extender

weight

Too heavy — weight

weight

Whatever height you choose, you can determine the weight of the letter. The body of the Bookhand letter is about 5 nibs tall, with extenders about 3 nibs up and down. The alphabet that is written just a little lighter will look more graceful and delicate without getting spindly; the alphabet that is written just a little heavier will gain power and permanence without getting chunky.

Stay within the limits of these _moderate letter weights_ to give full expression to the transition that the curved strokes make from thick to thin. Too little weight weakens the dramatic contrast between thick & thin strokes; too much weight obliterates the thin strokes.

The Bookhand alphabet, at heart, is about moderation. Enjoy its balanced simplicities by practicing it at moderate height and weight, using a comfortable calligraphy pen.

# BASIC STROKES

*Bookhand is based on simple geometric lines and curves. Practice separate strokes before joining them to make letters.*

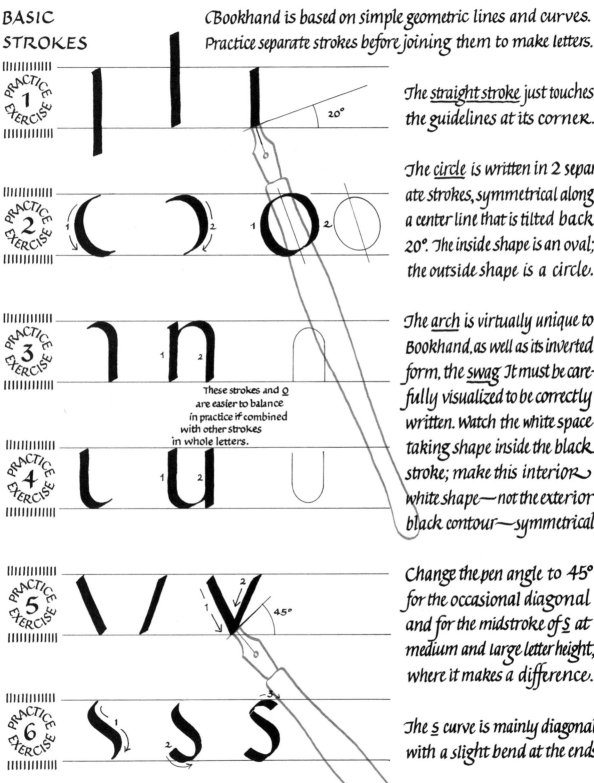

**PRACTICE EXERCISE 1**

The <u>straight stroke</u> just touches the guidelines at its corner.

20°

**PRACTICE EXERCISE 2**

The <u>circle</u> is written in 2 separate strokes, symmetrical along a center line that is tilted back 20°. The inside shape is an oval; the outside shape is a circle.

**PRACTICE EXERCISE 3**

These strokes and <u>o</u> are easier to balance in practice if combined with other strokes in whole letters.

The <u>arch</u> is virtually unique to Bookhand, as well as its inverted form, the <u>swag</u>. It must be carefully visualized to be correctly written. Watch the white space taking shape inside the black stroke; make this interior white shape—not the exterior black contour—symmetrical.

**PRACTICE EXERCISE 4**

**PRACTICE EXERCISE 5**

45°

Change the pen angle to 45° for the occasional diagonal and for the midstroke of <u>s</u> at medium and large letter height, where it makes a difference.

**PRACTICE EXERCISE 6**

The <u>s</u> curve is mainly diagonal with a slight bend at the ends.

# o b p t

TOUCH     MEET     OVERLAP     CROSS     JOINS

*There are four ways to connect the basic Bookhand strokes.*

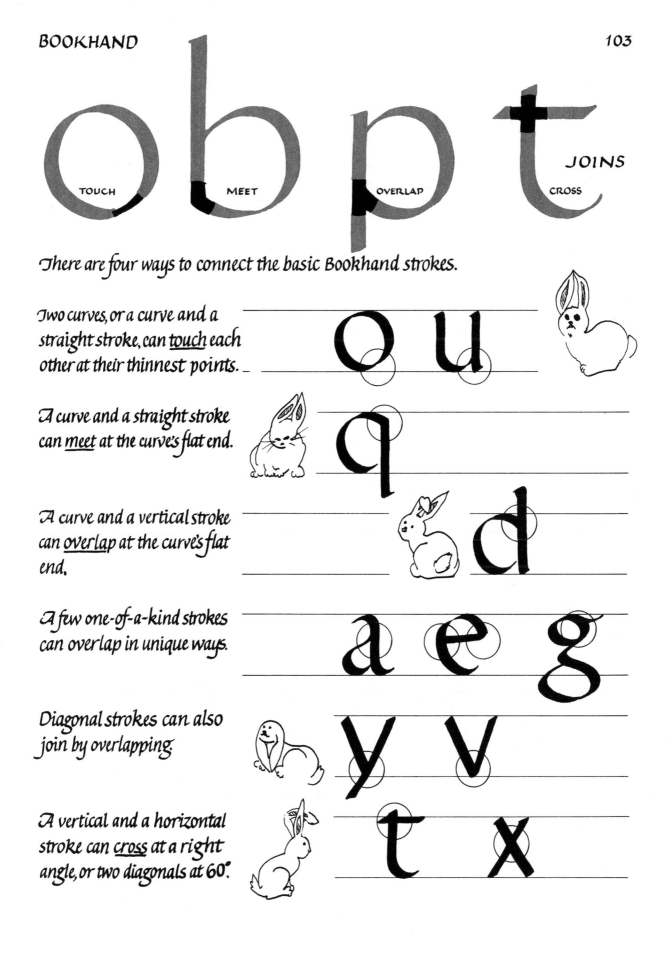

*Two curves, or a curve and a straight stroke, can <u>touch</u> each other at their thinnest points.*

o u

*A curve and a straight stroke can <u>meet</u> at the curve's flat end.*

q

*A curve and a vertical stroke can <u>overlap</u> at the curve's flat end.*

d

*A few one-of-a-kind strokes can overlap in unique ways.*

a e g

*Diagonal strokes can also join by overlapping.*

y v

*A vertical and a horizontal stroke can <u>cross</u> at a right angle, or two diagonals at 60°.*

t x

## BOOKHAND LETTER FAMILIES

Made from half a dozen simple geometric strokes that join in four ways, Bookhand letters are easy to group into families based on some characteristic like <u>width</u> or a common shape. Extra similarities within families may pair some letters in special relationships that define their identity. The main groups are based on letter <u>width</u>.

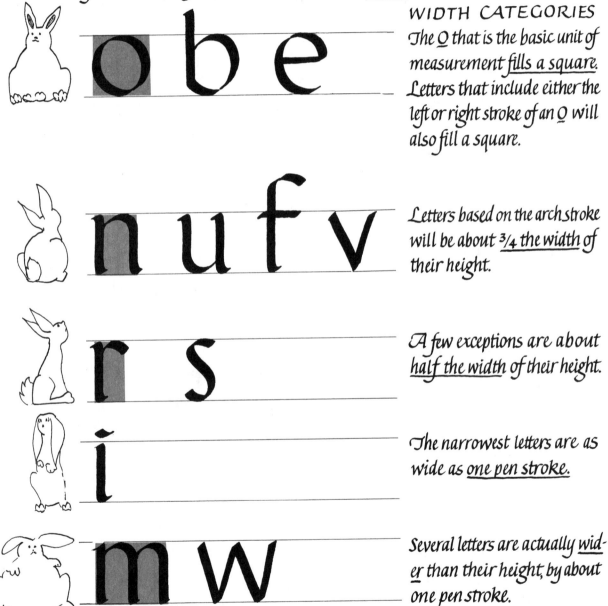

### WIDTH CATEGORIES

The <u>o</u> that is the basic unit of measurement <u>fills a square</u>. Letters that include either the left or right stroke of an <u>o</u> will also fill a square.

Letters based on the arch stroke will be about <u>¾ the width</u> of their height.

A few exceptions are about <u>half the width</u> of their height.

The narrowest letters are as wide as <u>one pen stroke.</u>

Several letters are actually <u>wider</u> than their height, by about one pen stroke.

# IDENTICAL TWINS AND PROBLEM CHILDREN IN LETTER FAMILIES

Turn page upside-down to see similarities.

*Certain letters within letter families have an identical twin whose existence may not be obvious until you notice that one of them is standing upside down. (Some may dress a little unlike each other.) Match up these invertible twins, and let them solve their structural problems in tandem.*

Turn page upside-down.

MEET

OVERLAP

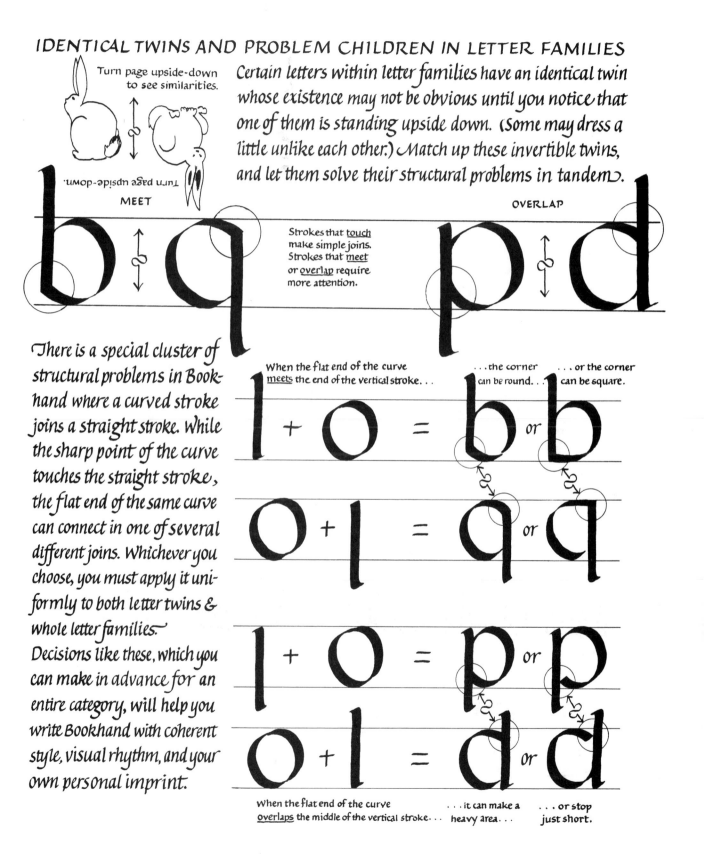

Strokes that <u>touch</u> make simple joins. Strokes that <u>meet</u> or <u>overlap</u> require more attention.

There is a special cluster of structural problems in Bookhand where a curved stroke joins a straight stroke. While the sharp point of the curve touches the straight stroke, the flat end of the same curve can connect in one of several different joins. Whichever you choose, you must apply it uniformly to both letter twins & whole letter families.
Decisions like these, which you can make in advance for an entire category, will help you write Bookhand with coherent style, visual rhythm, and your own personal imprint.

When the flat end of the curve <u>meets</u> the end of the vertical stroke...     ...the corner can be round...     ...or the corner can be square.

l + o = b or b

o + l = q or q

l + o = p or p

o + l = d or d

When the flat end of the curve <u>overlaps</u> the middle of the vertical stroke...     ...it can make a heavy area...     ...or stop just short.

BOOKHAND

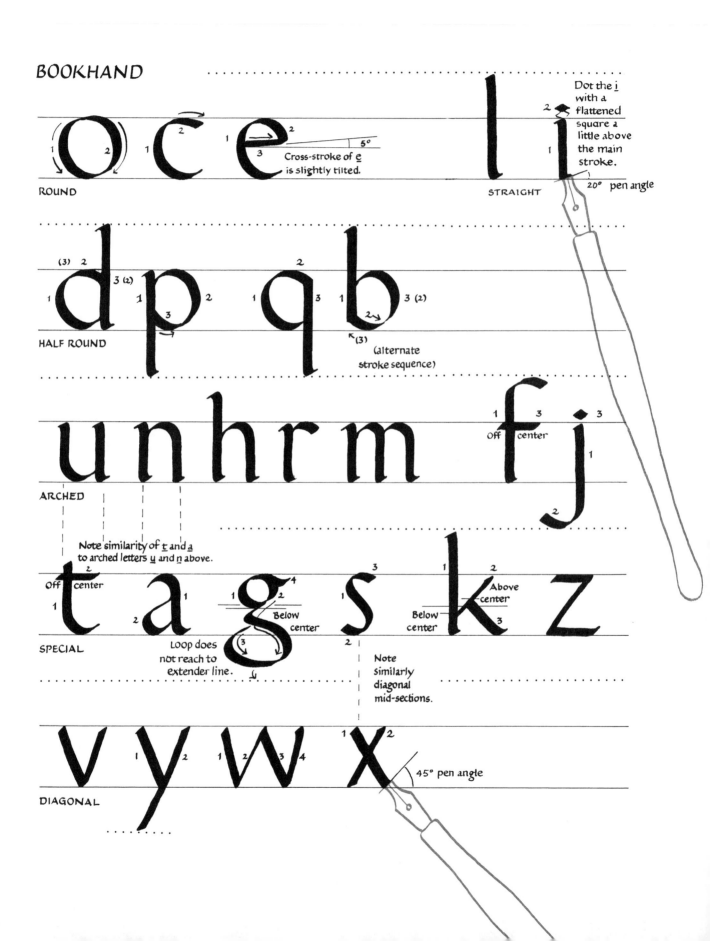

ROUND

Cross-stroke of _e_
is slightly tilted.

5°

STRAIGHT

Dot the _i_
with a
flattened
square a
little above
the main
stroke.

20° pen angle

HALF ROUND

(alternate
stroke sequence)

ARCHED

Off center

Note similarity of _t_ and _a_
to arched letters _u_ and _n_ above.

SPECIAL

Off center

Loop does
not reach to
extender line.

Below
center

Above
center

Below
center

Note
similarly
diagonal
mid-sections.

DIAGONAL

45° pen angle

Use a copier or scanner to enlarge or reduce the guidelines to fit the width of the pen you are using.

A serif motion closes up this gap.

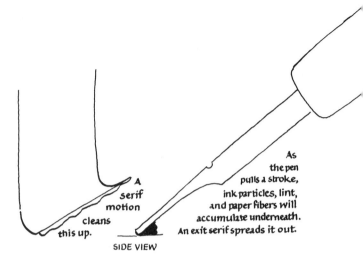

## SERIFS

A serif finishes off the stroke ends with a small sideways motion that serves many purposes. It covers the central nib split at the beginning of the stroke and distributes the accumulated ink at the end; it rounds off the corners of square spaces within and between letters; it expresses the underlying motions of the pen from stroke to stroke; and it gives the 26 individual letters a unified style.

A serif motion cleans this up.

As the pen pulls a stroke, ink particles, lint, and paper fibers will accumulate underneath. An exit serif spreads it out.

SIDE VIEW

WITHOUT SERIFS

WITH SERIFS

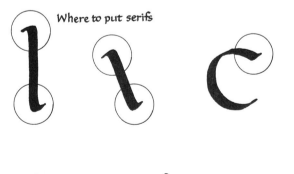

Where to put serifs

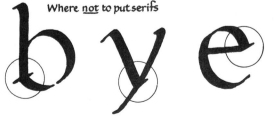

Where **not** to put serifs

## WHERE TO PUT SERIFS ON LETTERS

Serifs belong on thick strokes that do not already meet or overlap another stroke. But they do not belong on the thin unattached end of a curve, and are optional on the thick end of a curve.

As a beginner, your task will be to prevent your natural inclination—to begin and end every stroke with serifs—from creating a bristly little tangle at every corner join.

Visualize a center line.

Curve stroke to intersect guideline and center line.

Serif is made of small curve plus hairline.

## SERIF SIZE
Keep your Bookhand serif small at first, so as not to slow down or disrupt either your rhythm of writing or your reader's rhythm of reading.
The curve at the bottom and top of your letter should just touch the guidelines or, in larger sizes, overlap them slightly.

**BASIC BOOKHAND WITH SERIF**

# abcdefghijklm
# nopqrstuwwxyz

Bookhand serifs can take hundreds of slightly different shapes, from a thin hairline to a formal construction. As you master the basics, observe and evaluate other scribes' serifs.

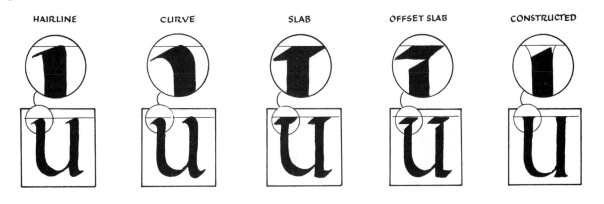

HAIRLINE     CURVE     SLAB     OFFSET SLAB     CONSTRUCTED

## SPACING

Bookhand letter spacing is based on the <u>area</u> between the right stroke of one letter and the left stroke of the next. Visualize an ant farm that holds the same bucket of sand no matter what shape container supports it. The letter edges that form these spaces can be classified as straight upright and diagonal, round closed, and complex open.

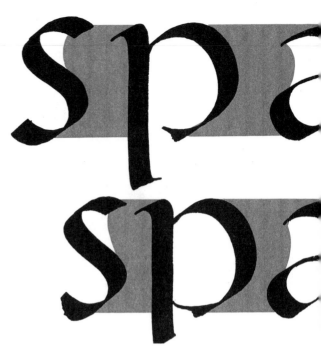

The basic unit of spacing is the rectangle made by 2 <u>straight</u> strokes, about half the width of its height. For <u>diagonals</u>, the eye reconfigures this into a triangle of equivalent area.

The spaces between <u>round closed</u> strokes form crescents, hour glasses, and concave triangles that cover the same amount of white space as the standard rectangle.

The space formed by <u>complex open</u> strokes will be simpler to estimate if you squint a little to permit your eye to determine the letter's edge without trying to analyze it.

Broad spacing

Tight
spacing

Cramped spacing

## VARIABLE LETTER SPACING

The calligrapher can tighten or loosen the spacing of letters and words. This will let you "justify" the margins by shortening or lengthening the line. As a beginner, you will do best to letter each line first in rough draft, judge whether to squeeze or stretch the spacing, and then copy it over. You will probably start by making just a few adjustments to the spaces between words; then try lots of small adjustments to the spaces between letters (left). Don't even think of trying to stretch or squeeze the letters themselves; the eye will detect it and reject it right away as distortion. Hyphenate some words, change line length, or simply switch to a slightly smaller letter with a smaller pen.

Try these ways to control the line length when letter spacing doesn't work.

| | | |
|---|---|---|
| to space the let-<br>ter itself, and<br>then the word | to space the<br>letter itself,<br>and then the | to space the letter<br>itself, and then<br>the word, until a |
| Hyphenate. | Change line length. | Choose smaller letter and pen size. |

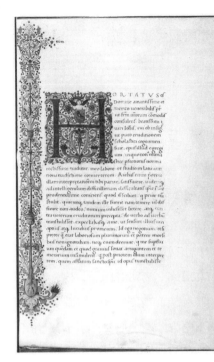

Didymus Alexandrinus. Courtesy Pierpont Morgan Library (see enlarged detail, next page).

## TRADITIONAL OR CONTEMPORARY BOOKHAND PAGE DESIGN

*You can make Bookhand letters look historically accurate on the page by using traditional rules: wide letters, thin serifs, generous spacing. A space the height of 2 letter bodies should separate the lines. Aim for between 3 and 9 words per line. The block of text should be narrower than its height, with proportions of about 2 to 3. The top margin should be smaller than the bottom. Center the text side-to-side or, to evoke the open book page, make the left margin 2/3 the width of the right margin.*

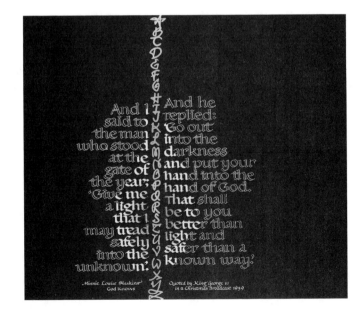

*Bookhand letters, however, also lend themselves to lively and original designs. Your own visual judgment as you advance will help you expand or challenge traditional rules: try dramatic serifs, tight spacing, uneven guidelines, many or few words per line, ragged margins, or horizontal proportions.*

rectissime traditur.

noua tradictione co

illam interpretatioc

ad intelligendum o

prudentissime con

stulit. quicunq̃ tar

finire non audeo. n

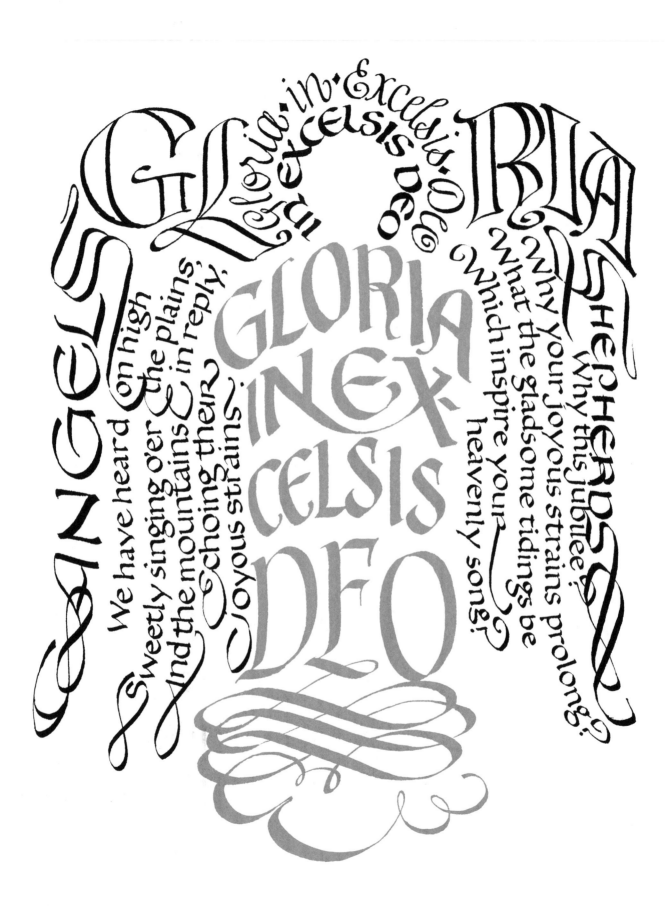

GLORIA in Excelsis Deo

ANGELS

Gloria in Excelsis Deo in Excelsis Deo

GLORIA

We have heard on high
Sweetly singing o'er the plains,
And the mountains in reply,
Echoing their
Joyous strains.

GLORIA IN EX- CELSIS DEO

SHEPHERDS,
Why this jubilee?
Why your joyous strains prolong?
What the gladsome tidings be
Which inspire your
heavenly song?

### CHOOSING A BOOKHAND TEXT

Bookhand lends simple elegance to calligraphy designs where the reader should be able to understand the text without effort. It is pleasant to read in long passages, offering a lovely, subtle texture on the page. It expresses quotations of lucid rationality, prose, poetry, insightful meditation, and practical philosophy. It tones down the energy of humor and lightens the weight of pomp. Almost the only occasion it does not enhance is the text of a ceremonial proclamation; it just isn't dressy enough to deliver a sermon or award a diploma.

Think of Bookhand as a clarifier, sharpening the focus rather than adding a layer of decoration. Or imagine it as vanilla, which brings out the flavors of many different ingredients and appeals to many palates.

Transparent, however, is not the same as invisible, and vanilla is still a flavor. Bookhand is simple, subtle, and familiar, but it is not neutral. Certain authors, nations, and times, in fact, are strongly identified with this letter for its special associations. The words of 20th-century American poet e e cummings, for instance, belong in Bookhand for its equivalence to the lowercase Roman type he used without conventional capitalization. And American authors in general benefit from Bookhand; those of the 18th and early 19th centuries, in particular, deserve a letter that reflects their search for genuine American forms of political and artistic expression. If you enjoy this dimension of the Bookhand style, read American authors like Ralph Waldo Emerson, Henry David Thoreau, Thomas Jefferson, Walt Whitman, and Emily Dickinson for texts.

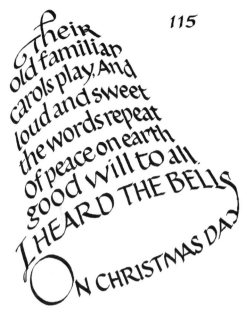

Their old familiar carols play, And loud and sweet the words repeat of peace on earth good will to all. I HEARD THE BELLS ON CHRISTMAS DAY

Go confidently in the direction of your dreams! Live the life you've imagined!

As you simplify your life, the laws of the universe will be simpler; solitude will not be solitude, poverty will not be poverty, weakness not weakness. THOREAU

John I never had a hat, never wore one, but recently was given a brown suede duck-hunting hat. The moment I put it on, I realized I was starved for a hat. I kept it warm by putting it on my head. I made plan's to wear it especially when I was going to do any thinking. Somewhere in Virginia, I lost my hat. cage

I
once
came across
an early book
about navigation
of the air, published in
the eighteenth century,
and was enchanted by a
suggestion the author made
for the invention of AIRSHIPS.
The idea was that people should go

THAT to the tops of high mountains and there
collect the fine, pure, light, rarefied air

IS WHAT of the summits, and put it into bags,                    And
and seal the bags, and bring          there, by

LOVERS OF them down to the          attaching
common level          the upward
of every-          lift of those

FINE BOOK S          day.          bags to a raft,
they can be

FIND IN THE BOOKS          used as an

THAT THEY LOVE —          airship.

THE LIGHTER AIR OF THE airship.

MOUNTAIN PEAKS OF HUMAN LIFE

Natural objects
can inspire
calligraphic designs.

PUSHING THE EDGE
Because Bookhand is so
easy to read, it is a good
alphabet to use when you
want to experiment with
untraditional layout. If
you plan lines of lettering
that will tilt, curve, or turn
upside-down, you can help
your readers understand
the words by using the
most familiar alphabet.
Look for strong simple images
that can be brought to life by
arranging letters on a page.

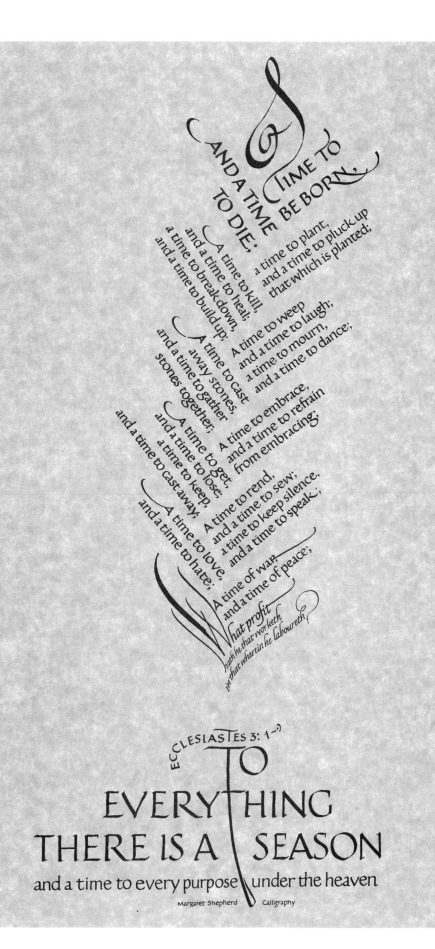

AND A TIME TIME TO
TO DIE; BE BORN,
A time to plant,
and a time to kill; and a time to pluck up
a time to heal; that which is planted;
and a time to break down,
and a time to build up,
A time to weep
and a time to laugh;
A time to cast a time to mourn,
away stones, and a time to dance;
and a time to gather
stones together;
A time to embrace,
A time to get, and a time to refrain
and a time to lose; from embracing;
a time to keep,
and a time to cast away;
A time to rend,
A time to love, and a time to sew;
and a time to hate; a time to keep silence,
and a time to speak;
A time of war,
and a time of peace;
What profit
hath he that worketh
in that wherein he laboureth?

ECCLESIASTES 3: 1—9
TO
EVERYTHING
THERE IS A SEASON
and a time to every purpose under the heaven

Margaret Shepherd      Calligraphy

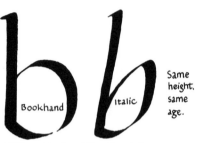

Parent is a little shorter than offspring.

Roman Bookhand

## BOOKHAND COEXISTS WITH ROMAN & ITALIC

Bookhand uses the Roman letters (pages 29~46) to capitalize words. Except for chapter openers, the capitals should be taller than the letter body but shorter than the extenders; they should be lettered with the same pen; they should start and end with the same serif.

Bookhand often brings along its sibling Italic, who speaks up in a contrasting visual voice to change meaning or add emphasis. Born in the early Renaissance as manuscript letters, but then adopted and brought up by the printing press, Bookhand and Italic share many family traits: size,

Bookhand Italic

Same height, same age.

Different bodies, different posture.

weight, line ratio, lowercase "small letter" status, even a tolerance for monoline expression. They cooperate visually when they appear together on the same page.

Handlettered or typeset, however, Italic has a distinct identity of its own. While each Bookhand letter is constructed of separate pen strokes, an Italic letter, or even several letters, can be completed with one single, uninterrupted stroke of the pen. While Bookhand letters are based on half a dozen basic shapes, all but 5 of the Italic letters are built on just one basic shape. And while Bookhand is almost always vertical, Italic is almost always slanted.

Like most siblings, Bookhand and Italic will coexist most happily if you don't blur who they are. Keep them sharply distinct from each other, and put them to work doing what they do best. Bookhand looks better the more carefully you write it; Italic blossoms when you relax and write more casually.

Bookhand and Italic are two different forms; fraternal twins, not identical twins.

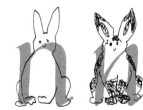

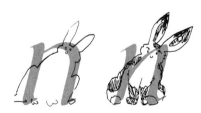

# ital[i]c

talic letters emerged in the early years of the Renaissance and continue to be written today. This style belonged not only to the monastic scribe and the professional copyist, but also to the law clerk, the scientist, the man of letters, the artist, the scholar, and the politician. Petrarch and Michelangelo had exemplary handwriting. Leonardo da Vinci, master of so many professions, could write backward and forward, with either hand.

Italic letters got their name from an Italy that was becoming the dominant cultural force after the Middle Ages. Model letters by Italian writing masters spread throughout literate Europe and the world in private correspondence, professionally copied edicts, and the new medium of paper and the printing press.

The visual beauty of Italic, and its capacity to express both public and private language, helped the script survive the 18th and 19th centuries, when flexible-pen French handwriting and pointed-pen Copperplate engraving pushed Italic out of fashion. The Arts and Crafts Movement of late Victorian England and the American calligraphy revival in the 1970's brought back Italic virtually unchanged from Renaissance alphabets.

People who pick up a pen or marker today — and tomorrow — will find that Italic beautifies their everyday handwriting while it introduces them to the calligrapher's art.

## CHOOSE A LETTER SIZE

Practice Italic small at first, around 1 cm (³⁄₈"). Small letters offer 3 advantages:

The Italic letter is shaped by small hand motions, not large arm motions. Study the large letters given here, but practice them at small or medium size.

Most Italic letters, and some groups of letters, are written in one stroke without lifting the pen. The smaller the letter, the fewer the lifts. A larger letter makes you interrupt the line between nearly every stroke.

Although calligraphers have used Italic many ways at many sizes, this alphabet still expresses itself best at a size that fits the printed page and the handwritten note. 500 years of familiarity in this context means that Italic will speak most clearly to the reader at a moderate, not monumental, scale.

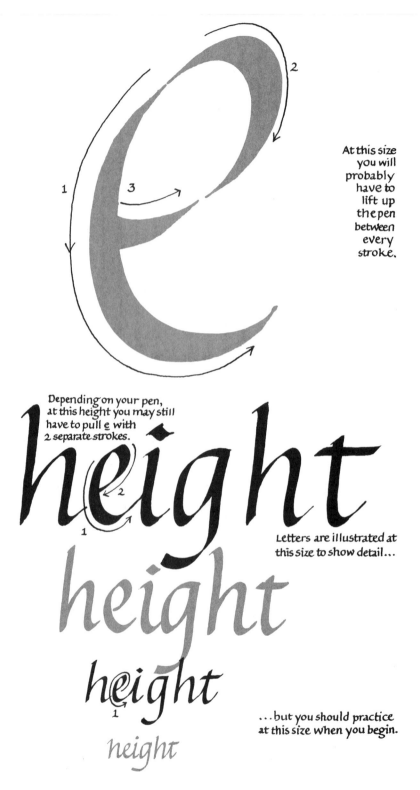

At this size you will probably have to lift up the pen between every stroke.

Depending on your pen, at this height you may still have to pull e with 2 separate strokes.

Letters are illustrated at this size to show detail...

...but you should practice at this size when you begin.

maximum line contrast
low line contrast
no line contrast

## AVOID EXTREMES OF WEIGHT

Italic is sensitive about its weight. Even a bit too much obliterates the key Italic curve where it merges with the upright, while too little makes it visually weak.

## LINE CONTRAST

The contrast between thick and thin will be different for different pens. A sharp dip pen writes a letter with high contrast, but it may also make trouble by digging into the paper surface. A blunt fountain pen or marker writes a letter with low contrast between thick and thin, but it glides over the paper without a snag. You balance these advantages & disadvantages with the kind of pen you choose. Italic letters look good both ways—written with a sharp pen for high contrast or with a blunt pen for low contrast. They even look good written without a calligraphy pen for no contrast. If you want to, or have to, you can practice and write a perfectly adequate Italic script with the unvarying monoline of a ballpoint, pencil, or marker.

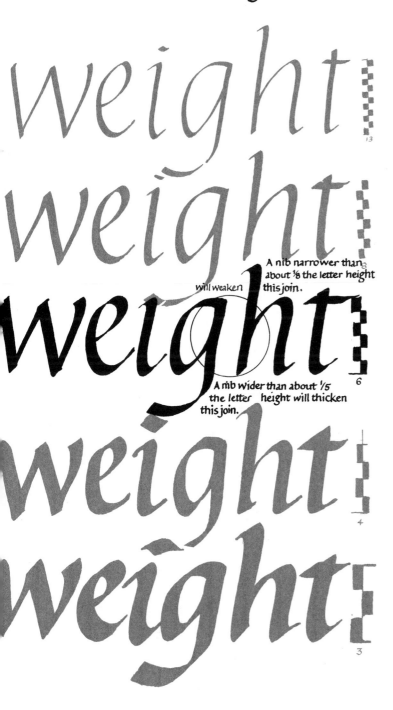

weight

weight
13

A nib narrower than about ⅛ the letter height will weaken this join.

weight
8

A nib wider than about ⅕ the letter height will thicken this join.
6

weight
4

weight
3

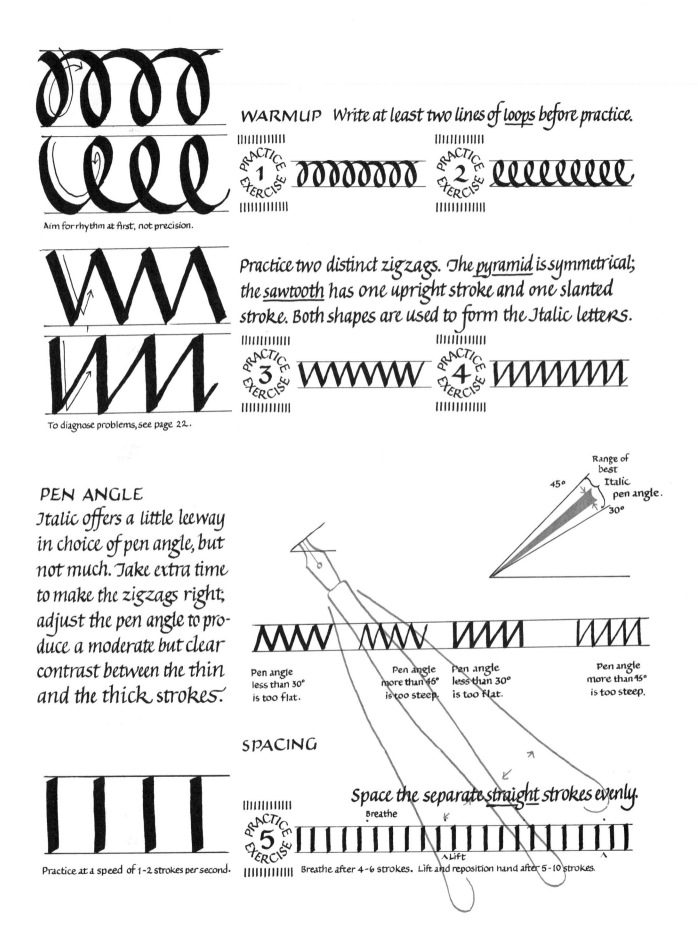

WARMUP  Write at least two lines of loops before practice.

Aim for rhythm at first, not precision.

PRACTICE EXERCISE 1

PRACTICE EXERCISE 2

Practice two distinct zigzags. The pyramid is symmetrical; the sawtooth has one upright stroke and one slanted stroke. Both shapes are used to form the Italic letters.

PRACTICE EXERCISE 3

PRACTICE EXERCISE 4

To diagnose problems, see page 22.

## PEN ANGLE

Italic offers a little leeway in choice of pen angle, but not much. Take extra time to make the zigzags right; adjust the pen angle to produce a moderate but clear contrast between the thin and the thick strokes.

Range of best Italic pen angle.

45°

30°

Pen angle less than 30° is too flat.

Pen angle more than 45° is too steep.

Pen angle less than 30° is too flat.

Pen angle more than 45° is too steep.

## SPACING

Space the separate straight strokes evenly.

Practice at a speed of 1-2 strokes per second.

PRACTICE EXERCISE 5

Breathe

Lift

Breathe after 4-6 strokes. Lift and reposition hand after 5-10 strokes.

## LETTER BODY BASICS

*Italic letter bodies are about 5 nibs tall. The most common stroke, <u>downstrokes</u> are about 3 nibs apart.*

Visualize objects in the real world that have proportions of 3 to 5: a face, a torso, a flower pot, a window, a book page, a soup can, even the fingers of a human hand.

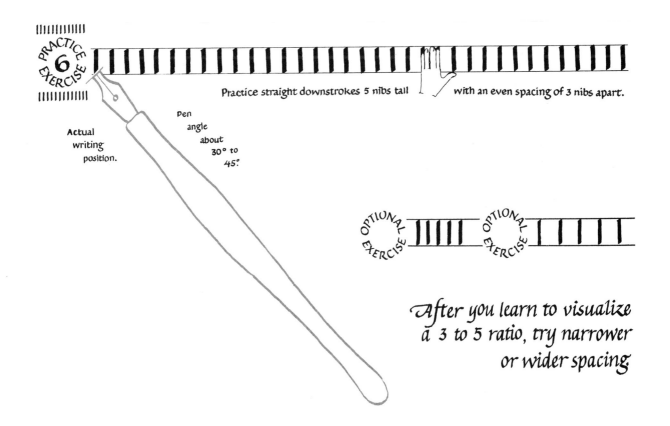

PRACTICE EXERCISE **6**

Practice straight downstrokes 5 nibs tall with an even spacing of 3 nibs apart.

Actual writing position.

Pen angle about 30° to 45°.

OPTIONAL EXERCISE          OPTIONAL EXERCISE

*After you learn to visualize a 3 to 5 ratio, try narrower or wider spacing*

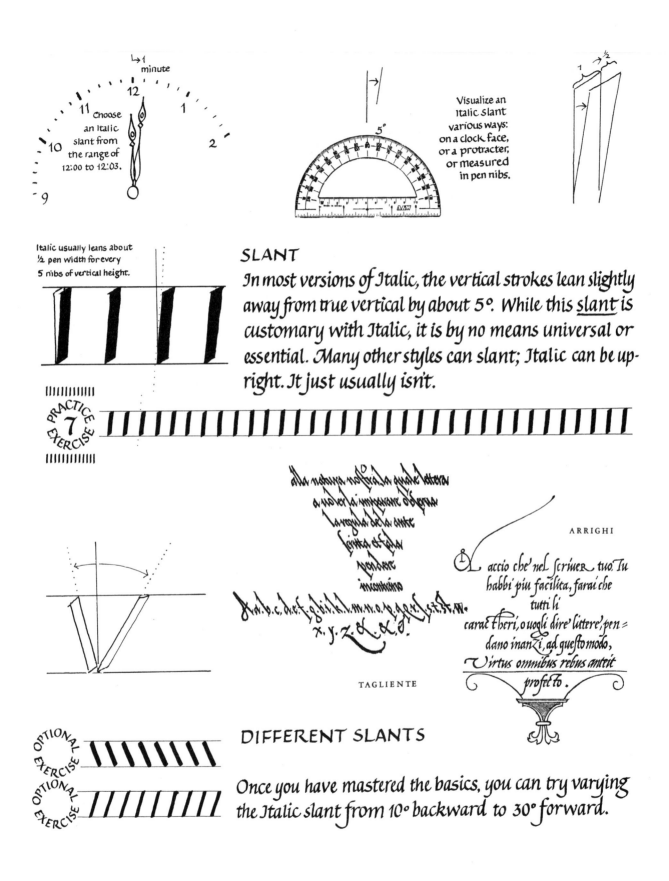

→1 minute

Choose an Italic slant from the range of 12:00 to 12:03.

5°

Visualize an Italic slant various ways: on a clock face, or a protracter, or measured in pen nibs.

Italic usually leans about ½ pen width for every 5 nibs of vertical height.

## SLANT

In most versions of Italic, the vertical strokes lean slightly away from true vertical by about 5°. While this <u>slant</u> is customary with Italic, it is by no means universal or essential. Many other styles can slant; Italic can be upright. It just usually isn't.

PRACTICE EXERCISE 7

ARRIGHI

TAGLIENTE

## DIFFERENT SLANTS

OPTIONAL EXERCISE

OPTIONAL EXERCISE

Once you have mastered the basics, you can try varying the Italic slant from 10° backward to 30° forward.

Alternating certainty and doubt
We travel in a world turned inside-out.

Not dreaming that our ornaments reflect
What's happened to the image we project.

Today is welcomed to the Calendar :
Tomorrow lies where all Greek Calends are.

Now let the terminal aggression cease:
Display the moral equivalent of Peace.

That elsewhere talk of PEACE ON EARTH can border
On that oxymoron, WORLD ORDER.

So spend the Christmas present at its prime :
You never can recycle wasted time.

Calligraphers can design their own personal Italic, and change it whenever they like. Shown here are the last two lines of an annual Christmas sonnet. Over the years, the artist has chosen various sizes, pen weights, pen angles, line contrasts, proportions, slant, and extender height.
Calligrapher: Margaret Fitzwilliam          Poet: Robert Fitzwilliam

The outlined strokes are each used in only one letter, T and F, which can be practiced later.

## EXTENDERS
Italic is mainly built on five vertical downstrokes of four different heights, spanning 1, 1⅓, 2, and 3 guidelines. The part that goes beyond the single guideline is the extender.

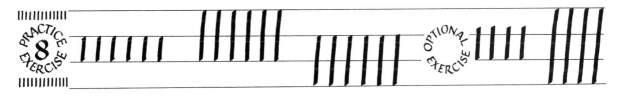

PRACTICE 8 EXERCISE

OPTIONAL EXERCISE

Practice slanted verticals in these 3 most useful heights.                    Practice less common extenders.

VARIABLE LINE SPACING

Use the guidelines on page 133 right side up for single-spaced lines...

... or turn them upside-down for double-spaced lines and large letter size.

ITALIC
uyuyuyuyuyuyuyuyuyuyug
agagagagagagagagagag
dadadadadadadadadada
ununununununununun
nhnhnhnhnhnhnhnhnh
hbhbhbhbhbhbhbhbhb
nmnmnmnmnmnmnmnm
itfitfitfitfitfitfi
ljljljljljljljljlj
vwvwvwvwvwvwvwv
nrnrnrnrnrnrnrnr
nknknknknknknknk
oooooooooooooooo
ccccccccccccccc
eeeeeeeeeeeeeeee
ssssssssssssssss
xxxxxxxxxxxxxxxx
zzzzzzzzzzzzzzzz

the quick brown fox jumps
over the lazy dog

angry gods just flocked up
to quiz and vex him

pack my box with five dozen
lacquer jugs

abcdefg
hijklmn
opqrstu
vwxyz

## FOUR DIAGONALS

As the pen travels diagonally up from the end of one stroke to the beginning of the next, it leaves behind it on the page one of these four distinctive marks. Two of them form the <u>transition</u> from one letter to the next; the other two connect the straight strokes together to form <u>the letter itself</u>. All these strokes have counterparts that have been rotated 180°, and occur at the top of the straight stroke. Turn the page upside-down to observe the kinship between stroke beginnings and stroke endings.

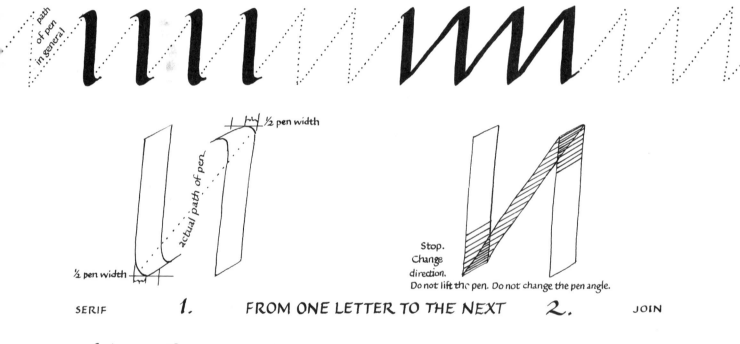

SERIF          1.          FROM ONE LETTER TO THE NEXT          2.          JOIN

Lift the pen off the paper at the end of the stroke with a little sideways curve and upward motion. Put the pen back down onto the paper at the top of the next stroke with the same motion. This curve and thin line is the <u>serif</u>. It occurs in other alphabets, too.

PRACTICE EXERCISE 9

Leave the pen touching the paper at the end of the stroke and go diagonally up to start the next stroke without curving the corner or lifting the pen. This line is the <u>letter join</u>. Italic is the only alphabet style that routinely connects letters this way.

PRACTICE EXERCISE 10

The two curves below are the key to the Italic style. No other alphabet has them. Although they can be diagrammed with lines and circles, they are so subtle and complex that you may find it easier to visualize them using the structure of your body.

LEAN ON YOUR LEFT * ELBOW AND LOOK IN A MIRROR ⌣     LOOK AT THE RIGHT * SIDE OF YOUR FACE IN A MIRROR ⌣

*Reverse these directions if you are looking at someone else.

The n curve leans away from the straight stroke the way your spine leans away from the straight backrest of the chair, then makes a rounded corner at your left shoulder, and then goes straight down to your elbow.

The u curve starts straight down from your left temple, turns the rounded corner of your chin, then curves back up to your right ear, and drops straight down along the main tendons of your neck.

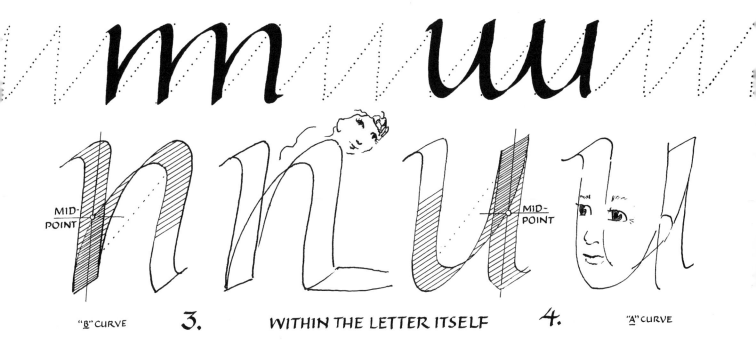

"B" CURVE     3.     WITHIN THE LETTER ITSELF     4.     "A" CURVE

At the bottom of the downstroke, leave the pen on the paper. Pause, reverse direction, and go back up, springing smoothly away from the stem at its midpoint. Round the upper corner at about one pen width, leaving a concave white triangle.

Start the downstroke, but round it by one pen width, leaving a concave white triangle at the corner. Visualize the next downstroke so that your diagonal upstroke can merge with it at its midpoint and coincide exactly with it at its top.

Visualize a plant.

PRACTICE EXERCISE 11

Visualize a drape.

PRACTICE EXERCISE 12

Test the shape of your curves by turning them upside-down.

**PUSH** ⟵

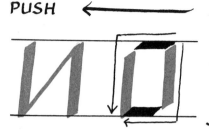

In addition to the left-to-right diagonals shown on the preceding two pages, Italic downstrokes can also be connected by right-to-left horizontal strokes. With a medium-size pen and smooth paper, you can push the horizontal strokes from right to left. This forms the letters in the right order.

A right-to-left pushed stroke may encounter some problems:

The paper may snag if the surface is soft, the pen is too sharp, or the weather is humid. Change to harder paper or a blunter pen.

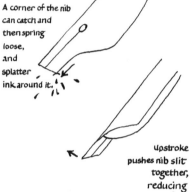

A corner of the nib can catch and then spring loose, and splatter ink around it.

Upstroke pushes nib slit together, reducing ink flow.

The ink may not continue to flow, especially in dry weather. Change to a narrower pen or a marker for practice and everyday projects.

The pushed motion may feel awkward. Change how you hold the pen. Move your entire arm. Sit differently. Practice more. Use a smaller pen and smoother paper. Just don't give up;* a flowing and organic Italic script demands that you learn at first by pushing and pulling the strokes without many lifts. If you start to pull every stroke, you won't understand the letter's structure.

\* If you've given up:

**PULL (OPTIONAL)**

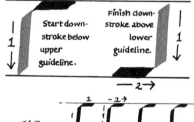

Start downstroke below upper guideline.

Finish downstroke above lower guideline.

If the pushed horizontals still give you trouble or if your design requires a large pen, or a sharp nib, or rough paper, you may have to lift the pen after each downstroke in order to pull every horizontal stroke. While this deconstructed letter will look correct, this technique slows down your writing & disrupts the natural motion of the pen. Avoid it at first.

OPTIONAL EXERCISE

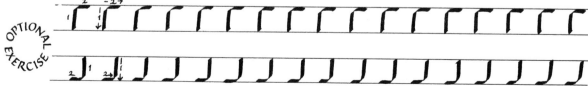

The extender stroke of <u>b</u> is shown shorter than usual, to emphasize its otherwise identical structure to an inverted <u>a</u>.

Turn page upside-down.

*The pushed horizontal stroke does two jobs in the Italic alphabet: it closes a letter body and it swashes an extender (next page). In closing a letter body, it rounds off the thin edge of one vertical stroke and connects squarely with the flat end of the other. This pushed horizontal stroke and the curved diagonal upstroke on page 127 are the basic key to the Italic alphabet.*

<u>b</u> follows the structure of <u>a</u>.

Visualize rounding off from an angular framework.

The left edge of the curved diagonal upstroke touches the exact midpoint of the vertical.

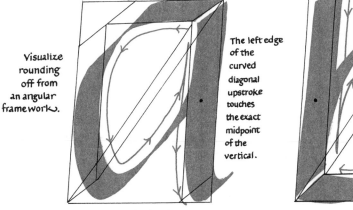

Watch this white triangle take shape.

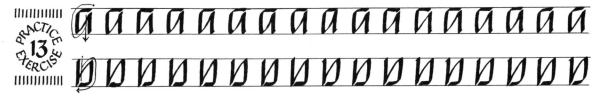

PRACTICE EXERCISE **13**

Practice this overly angular letter structure to master the pen's path. Then round the sharp corners as shown below.

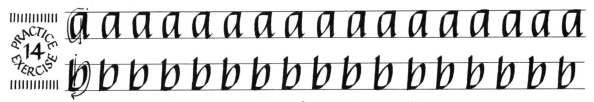

PRACTICE EXERCISE **14**

Practice these two fundamental letter bodies until they feel comfortable and look graceful.

## HORIZONTAL BEGINNINGS AND ENDINGS

*Swashes at the top and bottom of extenders follow the same rectangular structure as the horizontal strokes that connect verticals in letter bodies. It doesn't matter where these horizontal strokes occur in the letter structure: letter strokes, cross strokes, and swashes all look basically alike.*

### STANDARD PUSH

*In Italic handwriting, almost all of these horizontal strokes are <u>pushed</u> from right to left, forming whole letters and groups of letters without lifting the pen.*

### OPTIONAL PULL

*In Italic lettering almost all of these horizontal strokes are <u>pulled</u> from left to right in a series of separate pen motions, with the pen lifted between each stroke and the next.*

Guidelines are realigned here to illustrate the horizontal stroke as letter stroke, cross stroke, and swash — all basically the same stroke.

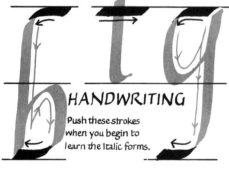

**HANDWRITING**

Push these strokes when you begin to learn the Italic forms.

PUSHED HORIZONTALS

Letters are shown here with slightly separated joins, to emphasize where the pen lifts up in contrast to where it stays on the paper.

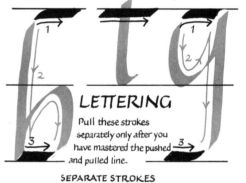

**LETTERING**

Pull these strokes separately only after you have mastered the pushed and pulled line.

SEPARATE STROKES

|||||||||||||

PRACTICE EXERCISE **15**

|||||||||||||

qb qb qb qb qb qb qb qb qb qb

|||||||||||||

PRACTICE EXERCISE **16**

|||||||||||||

gb gb gb gb gb gb gb gb gb gb

Beginners often curl up this stroke.
That is a mistake; it is nearly straight.

Letters made of a miscellaneous group of specialized strokes deviate from the framework of Italic while still harmonizing with it and with each other. They all relate to the underlying structure of the 3-by-5 Italic rectangle, connecting its corners and midpoints.

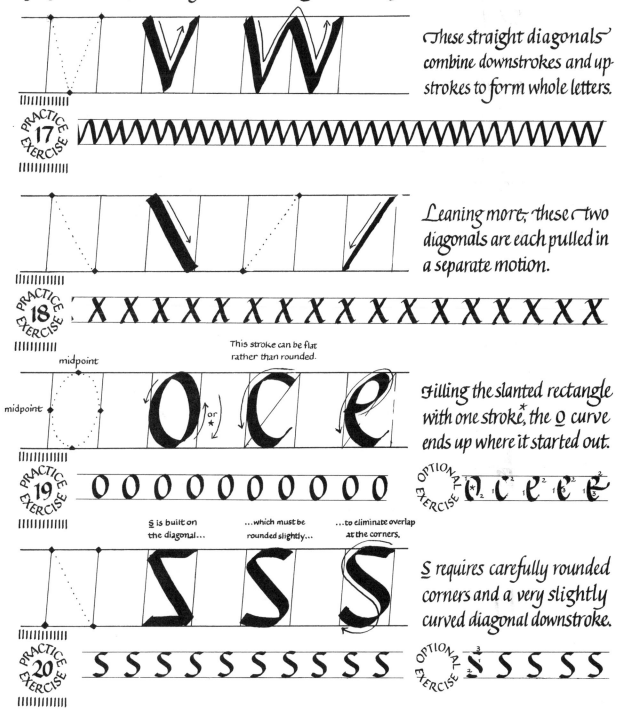

These straight diagonals combine downstrokes and upstrokes to form whole letters.

Leaning more, these two diagonals are each pulled in a separate motion.

This stroke can be flat rather than rounded.

midpoint

midpoint

Filling the slanted rectangle with one stroke,* the _o_ curve ends up where it started out.

_S_ is built on the diagonal...    ...which must be rounded slightly...    ...to eliminate overlap at the corners.

_S_ requires carefully rounded corners and a very slightly curved diagonal downstroke.

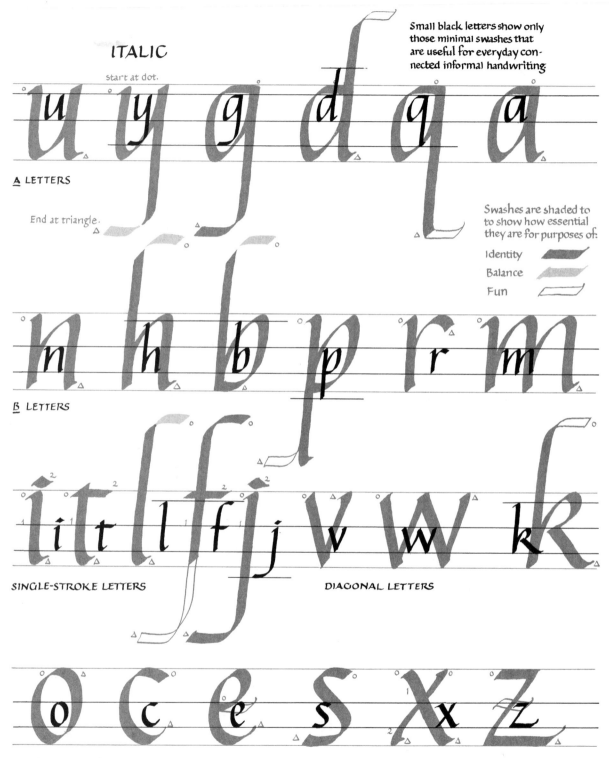

ITALIC

start at dot.

Small black letters show only those minimal swashes that are useful for everyday connected informal handwriting.

**A LETTERS**

End at triangle.

Swashes are shaded to to show how essential they are for purposes of:

Identity

Balance

Fun

**B LETTERS**

SINGLE-STROKE LETTERS            DIAGONAL LETTERS

SPECIAL LETTERS

THIS WAY UP. single space. Turn upside-down for double space and larger letters.

Use a copier or scanner
to enlarge or reduce the
guidelines to fit the width
of the pen you are using.

THIS WAY UP. Double space.   Use heavy lines for large letters.   Turn upside-down for single space.

## JOINING SOME ITALIC LETTERS WITH OTHERS

Italic is the only broad-edge Western alphabet that connects the letters, letting the pen-line flow across the page without lifting between every letter. <u>Not all</u> the letters, however, connect with all the others; study the categories shown here and the chart on page 136 to make the connections that promote both speed and rhythm.

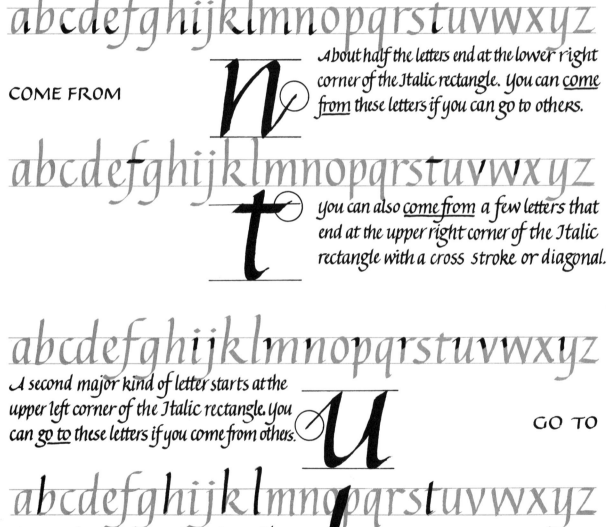

abcdefghijklmnopqrstuvwxyz

COME FROM

About half the letters end at the lower right corner of the Italic rectangle. You can <u>come from</u> these letters if you can go to others.

abcdefghijklmnopqrstuvwxyz

you can also <u>come from</u> a few letters that end at the upper right corner of the Italic rectangle with a cross stroke or diagonal.

abcdefghijklmnopqrstuvwxyz

A second major kind of letter starts at the upper left corner of the Italic rectangle. you can <u>go to</u> these letters if you come from others.

GO TO

abcdefghijklmnopqrstuvwxyz

you can also <u>go to</u> letters that start with an unswashed extender on the letter's left edge.

## THE LETTER JOIN

As you approach the end of a <u>come from</u> letter, look ahead. If the next letter is a <u>go to</u> letter, keep your pen on the paper to make the thin diagonal upstroke (or occasional cross stroke) that connects it to the next letter. If the next letter is <u>not a go to</u> letter, you cannot make a letter join without awkwardness and the risk of illegibility. End with a serif, lift your pen, and put it down at the beginning of the next letter.

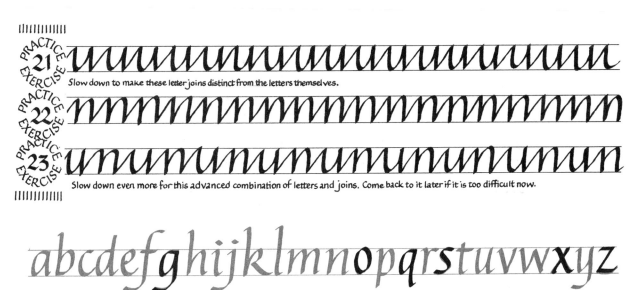

If you                 you can
<u>come from</u> these letters:      <u>go to</u> these letters

acedhiklmnftvw        ijmnprvwybhlkt

*PRACTICE EXERCISE 21*
Slow down to make these letter joins distinct from the letters themselves.

*PRACTICE EXERCISE 22*

*PRACTICE EXERCISE 23*
Slow down even more for this advanced combination of letters and joins. Come back to it later if it is too difficult now.

abcdefghijklmnopqrstuvwxyz

All the remaining letters should be written one at a time, <u>unconnected</u>, or connected only in special circumstances, using great care to avoid making them look like some other letter.

Dot the i and cross this t after you finish the next letter(s). You can also choose t

**COME FROM**

Come from the lower right corner of these letters.

GO TO — Go to the upper left corner of these letters.

Go to the middle of the left side of the letter.

| COME FROM → GO TO ↓ | u | and m / n | a | h | c | e | k | i | t |
|---|---|---|---|---|---|---|---|---|---|
| u | uu | nu | au | hu | cu | eu | ku | iu | tu |
| n (and m) | nu | nn | an | hn | cn | en | kn | in | tn |
| y | uy | ny | ay | hy | cy | ey | ky | iy | ty |
| p | up | np | ap | hp | cp | ep | kp | ip | tp |
| r | ur | nr | ar | hr | cr | er | kr | ir | tr |
| i | ui | ni | ai | hi | ci | ei | ki | ii | ti |
| j | uj | nj | aj | hj | cj | ej | kj | ij | tj |
| v (and y) | uv | nv | av | hv | cv | ev | kv | iv | tv |
| t | ut | nt | at | ht | ct | et | kt | it | tt |
| l | ul | nl | al | hl | cl | el | kl | il | tl |
| h | uh | nh | ah | hh | ch | eh | kh | ih | th |
| b | ub | nb | ab | hb | cb | eb | kb | ib | tb |
| k | uk | nk | ak | hk | ck | ek | kk | ik | tk |

cross the t first.

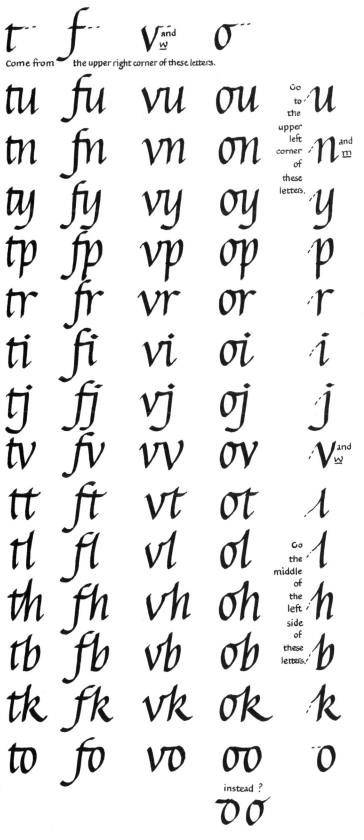

Come from the upper right corner of these letters.

Go to the upper left corner of these letters.

Go the middle of the left side of these letters.

instead ?

This chart shows the most useful Italic connections that come from one letter and go to the next. When you begin Italic, start with the connections shown in the upper left corner of the chart, and work carefully across a few columns, repeating each letter pair until the connection is comfortable to your hand and clear to your eye. Keep trying new pairs as you master the lower right of the chart, adding your favorites to your daily handwriting. This can be a leisurely process that you return to occasionally over many weeks and years, at various levels of expertise.

Try connecting most of your letters.
Try connecting none of your letters.

## LUCKY AND UNLUCKY CONNECTIONS

In addition to the natural connections you can make by not lifting the pen, some Italic letters

awkward

K joins w with a lucky connection.

connect with each other when the ends of strokes happen to meet, touch, or overlap. As your calligraphy gets more precise, particularly if you try larger, slower, more formal lettering in separate pulled strokes, you should watch for letter pairs with the potential for _elegant connections_ and enhance them.

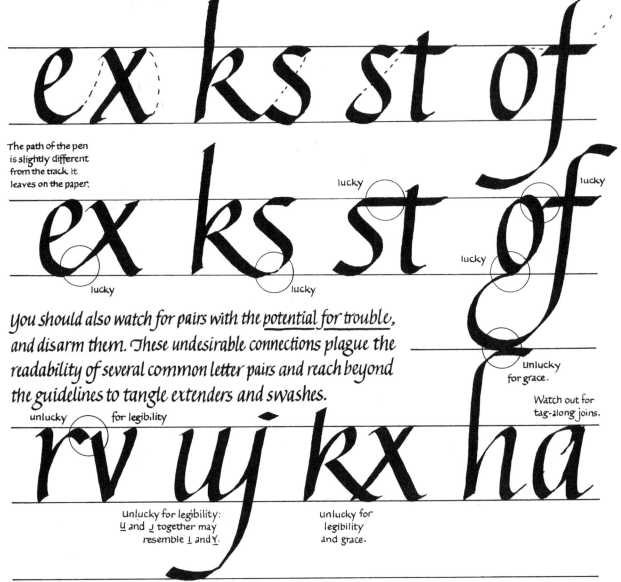

The path of the pen is slightly different from the track it leaves on the paper.

lucky    lucky    lucky    lucky    unlucky for grace.

You should also watch for pairs with the _potential for trouble_, and disarm them. These undesirable connections plague the readability of several common letter pairs and reach beyond the guidelines to tangle extenders and swashes.

Watch out for tag-along joins.

unlucky   for legibility

Unlucky for legibility: u and j together may resemble i and y.

unlucky for legibility and grace.

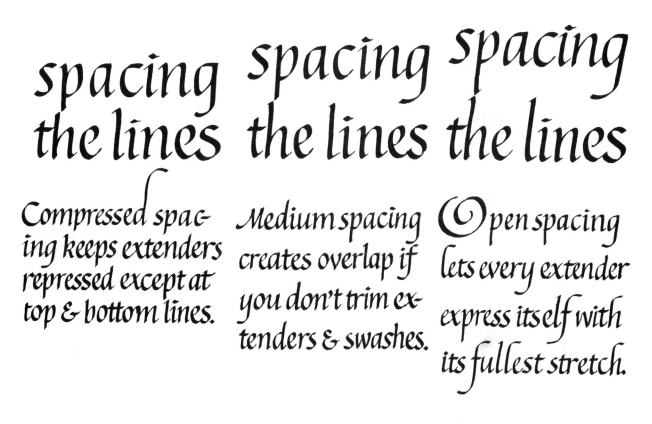

spacing the lines   spacing the lines   spacing the lines

Compressed spacing keeps extenders repressed except at top & bottom lines.

Medium spacing creates overlap if you don't trim extenders & swashes.

Open spacing lets every extender express itself with its fullest stretch.

Fix any tangled extenders on your Italic page with one of the following techniques:

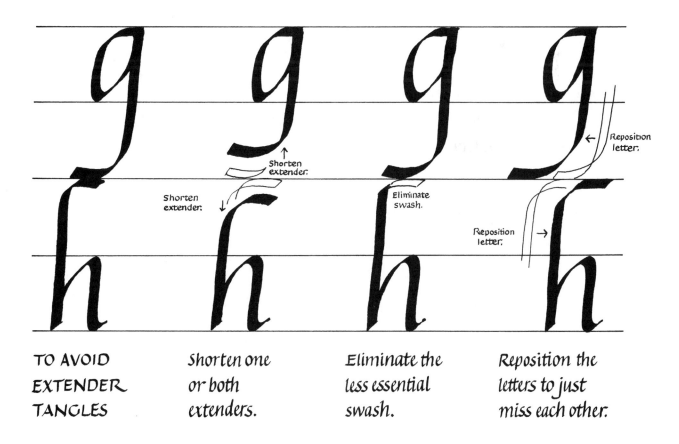

Shorten extender.

Shorten extender.

Eliminate swash.

Reposition letter.

Reposition letter.

TO AVOID EXTENDER TANGLES

Shorten one or both extenders.

Eliminate the less essential swash.

Reposition the letters to just miss each other.

I
want
everything
~love, children,
adventure,
intimacy
work

## BASIC ITALIC EVERY DAY
This fifteenth-century alphabet, brought back into fashion in the twentieth-century calligraphy revival, is so popular now that when people say "calligraphy" they usually have Italic in mind. Whether formally lettered or informally handwritten, Italic expresses all kinds of texts and appeals to all kinds of readers.

One more glass to see through darkly now:
time & time again makes all too clear
how moment settles swift on moment,
how sand can make a desert of
a year. See the world in a
grain of sand – now
minutely chang-

ing into

☒MAS TIDE

then –

yet in an hour
that world will tumble,
land upside down, be forced to
start again, particulate of gravity and
pain, all coming down to this: no turnabout
can turn time back to go against the grain: within
& yet forever running out it is the property of other
powers – this glass of hours is not completely ours.

AMPERSAND 1984

R&M FITZWILLIAM

Margaret Fitzwilliam

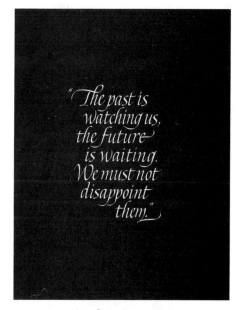

"The past is
watching us,
the future
is waiting.
We must not
disappoint
them."

Tom Costello

13 August 2000

*Letters in Gold*

Tom Costello

Dear Margaret,

Nice hearing from you and I wish you great success
with your book. Enclosed are some B/W examples of work
along with a few color copies of work that some gift
shops are carrying in Newport. You may keep all the
work. All is great here and I keep busy. Enjoy the
rest of the summer and keep calligraphy alive and well.
Stay well and happy. Let your imagination and hand
express itself with the written word.

Gratefully,
B.

Robert Boyajian

## VARIATIONS ON BASIC ITALIC

If letters are the clothing of words, you can't go wrong with Italic, the little black dress of your calligraphy wardrobe. Basic Italic goes everywhere, from the office to the opera house. You can dress it up or down, transforming the whole outfit with the simplest change of accessories and attitude.

**syncho-pation**

Jazz it up with a mix of size, slant, and placement.

**rigid** or **round**

Try sharp shoulders and straight posture, or soft shoulders and a shimmy.

**outline** or **reverse**

You can outline white Italic with a scroll pen or tandem pencils; or you can letter it with white ink on, or digitally drop it out of, a black background.

THE ULTIMATE ITALIC ACCESSORY IS A VIRTUAL SCARF

You can modify your basic Italic outfit a little further by lengthening any swash that is already part of the letter or adding a swash to any letter where it is optional. Visualize your swash as a long silk scarf, and explore it with pen on paper as if it really could crisscross, drape, and float.

ITALIC CAPITALS & SWASHES

ITALIC CAPITALS FIT IN TO THE HANDLETTERED MANUSCRIPT, OR THE PRINTED BOOK, OR THE HANDWRITTEN PERSONAL LETTER. CREATED IN THE RENAISSANCE, ITALIC CAPITALS RE-EMERGED AS A DISTINCT NEW STYLE, WELL SUITED TO THE CASUAL ELEGANCE OF THE 20TH CENTURY CALLIGRAPHY REVIVAL. SWASHES, WHICH GROW NATURALLY FROM ITALIC CAPITALS, CAN TAKE ON A SEPARATE LIFE OF THEIR OWN.

## CHOOSE A KIND OF PEN AND A SIZE

*When you choose a pen for swash practice, size is not as important as ease of use. Swashes should be pushed and pulled, back and forth in one continuous motion, without lifting the pen. In the beginning a marker of medium size will facilitate these large, smooth, rhythmic arm motions.*

*If you have been practicing the Italic small letters (pages 119~142), or if you already have a calligraphy pen, try out this zigzag to see if your materials have any problems with the pushed strokes; if they snag or dry up, you will need to choose a different pen or different paper*

Use a ballpoint, monoline marker, or pencil to practice swash motions without friction or snags.

PRACTICE EXERCISE 1

OPTIONAL EXERCISE

OPTIONAL EXERCISE

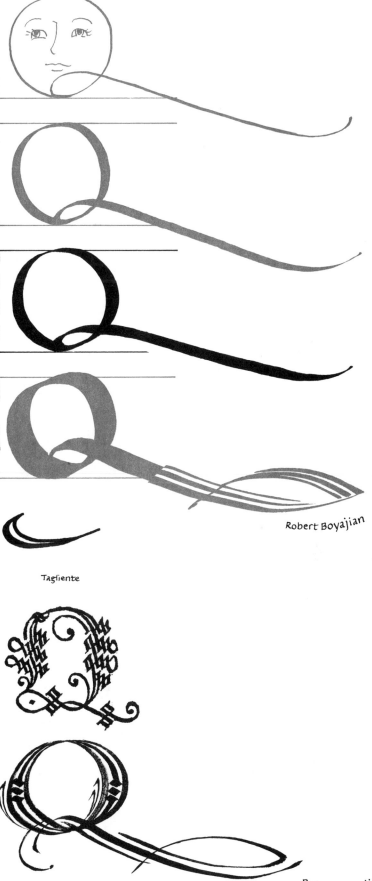

## LETTER WEIGHT

Some capitals and swashes are formed with single pen strokes. A narrow pen makes a light & elegant line; a wide pen makes a heavy and dramatic line. A thin stroke is harder to control physically because the pen digs into the paper if you lean on it; a thick stroke is harder to control visually because the strokes crowd each other.

## OTHER KINDS of PENS

A split stroke reinforces the visual energy of the stroke.

Tagliente

## PEN TEAMWORK

Some swashes just naturally create a doubled effect. You can repeat a line with strictly parallel strokes or intentionally unparallel strokes. Try pairs, trios, and bundles that add up to a whole letter. Combine lines of different weights and different ink colors.

Robert Boyajian

Robert Boyajian

**BB**

### BASIC ITALIC CAPITALS

Italic capitals are about 7 nibs high. They should always be shorter than the extenders of the small letters they accompany. If written as all capitals, without small letters, they should be the same height as each other.

If you shorten the extenders, you should make the capital smaller, too. It can shrink down to nearly the height of the letter body.

Bb Bb Bb Bb Bb

Italic capitals are based on the shapes of the classical Roman capitals (pages 29 ~ 46).

ABCDEFGHIJKLMNOPQRSTUVWXY

NOBMI

Position the pen at a steep 45° angle and keep it there for every letter. This gives vertical and horizontal strokes approximately the same weight.

ABCDEFGHIJKLMNOPQRSTUVWXY

NOBMI

Make the wide letters narrower and the narrow letters wider, until all the letters are about ¾ the width of their height. M and W will be slightly wider. Add strokes to broaden I.

ABCDEFGHIJKLMNOPQRSTUVWXYZ

NOBMZ

Slant the capitals about 5°, matching the Italic small letters they accompany.

ABCDEFGHIJKLMNOPQRSTUVWXYZ

NOBMZ

For a simple decorative effect without complicating the letter structure, dislocate the joins by shortening some strokes and lengthening others. Choose from 5 alternatives:

B DEF HIJ L    P R T

| over-lapped | vertical point | horizontal point | double point | rounded point |

Letters with these joins are shown on page 148.

### BASIC ITALIC CAPITALS ~ OVERLAPPED JOINS

ABCDEFGHIJKLMN

OPQRSTUVWXYZZ

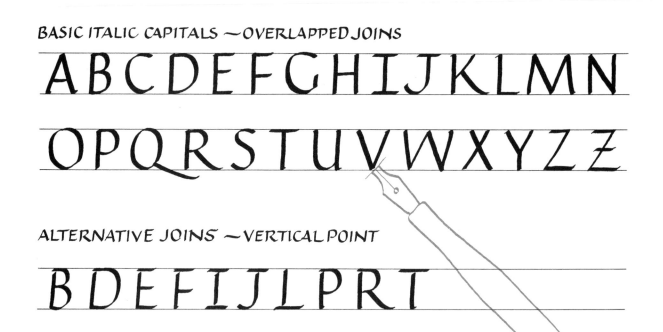

### ALTERNATIVE JOINS ~ VERTICAL POINT

BDEFIJLPRT

### HORIZONTAL POINT

BDEFHPR

### DOUBLE POINT

BDEFPR

### ROUNDED POINT

BDEFPR

### ITALIC LETTERS

See page 132.

abcdefghijklmnopqrstuvwxyz

# ITALIC SMALL LETTERS  Thin guideline.    Heavy guideline. ITALIC CAPITALS

extender

capital

ONLINE GUIDELINES
www.margaretshepherd.com

Use a copier or scanner
to enlarge or reduce the
guidelines to fit the width
of the pen you are using.

## SWASHES

Swashes don't have to stay attached to letters. They can stand alone or repeat to make borders. The basic spiral extends into a helix, and can curl clockwise or counter-clockwise.

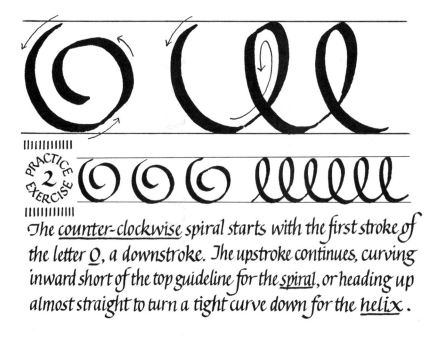

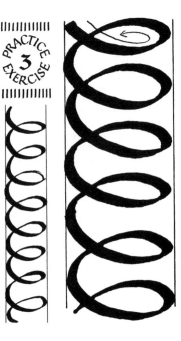

PRACTICE EXERCISE 3

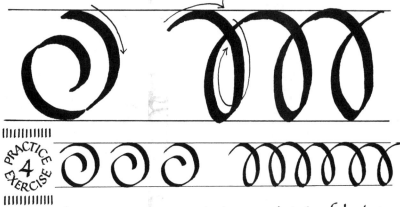

PRACTICE EXERCISE 2

The *counter-clockwise* spiral starts with the first stroke of the letter o, a downstroke. The upstroke continues, curving inward short of the top guideline for the *spiral*, or heading up almost straight to turn a tight curve down for the *helix*.

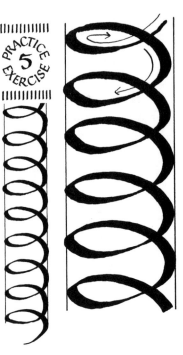

PRACTICE EXERCISE 5

PRACTICE EXERCISE 4

The *clockwise* spiral starts with the second stroke of the letter o, another downstroke. The upstroke continues, curving inward short of the lower guideline for the *spiral*, or heading down almost straight to turn a tight curve up for the *helix*

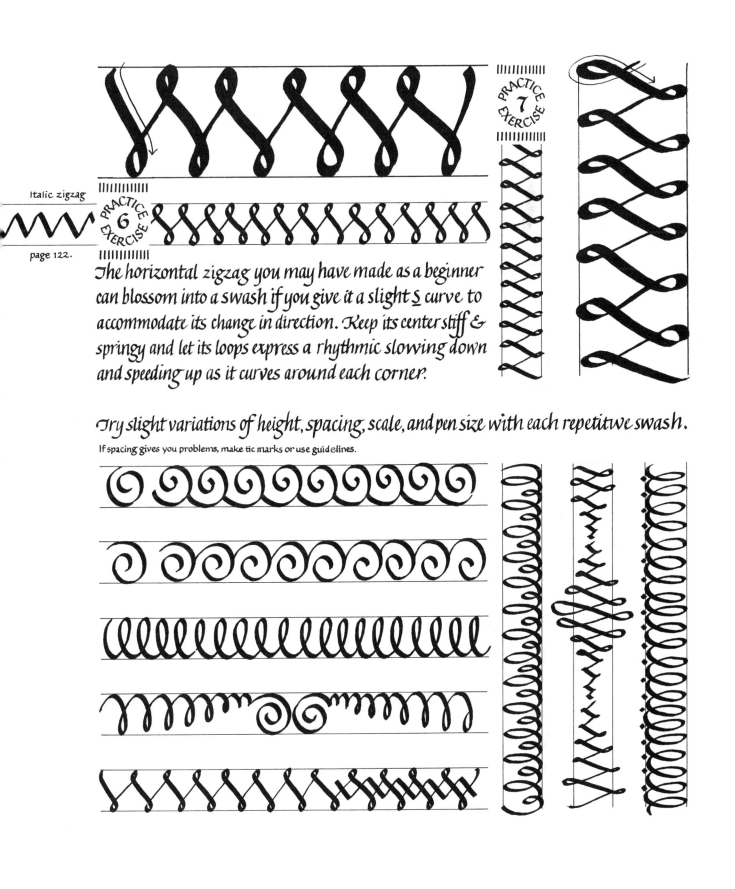

Italic zigzag

page 122.

PRACTICE EXERCISE 6

PRACTICE EXERCISE 7

The horizontal zigzag you may have made as a beginner can blossom into a swash if you give it a slight _S_ curve to accommodate its change in direction. Keep its center stiff & springy and let its loops express a rhythmic slowing down and speeding up as it curves around each corner.

Try slight variations of height, spacing, scale, and pen size with each repetitive swash.

If spacing gives you problems, make tic marks or use guidelines.

**LETTER SWASHES**          Like any favorite accessory, the Italic swash is supremely versatile. <u>Pin</u> a small swash to the letter. Let a short or medium swash <u>extend</u> from the letter. <u>Attach</u> a long swash to a corner or end of the letter. Or let a swash of any length <u>float</u> nearby, detached from but still visually part of the letter, word, or line.

PIN   EXTEND   ATTACH   FLOAT

Swashes can grow from and add on to the extenders of the Italic small letters, in much the same way they emerge from the Italic capitals. The same swash may be essential for a letter's identity, customary for its balance, or just for fun.

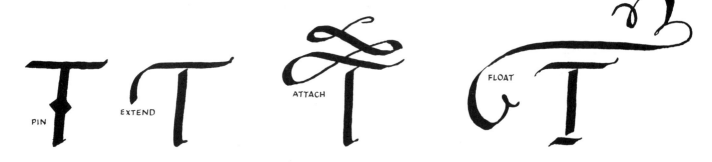

for identity   for balance   for fun   for fun   and to emphasize Q's difference from G.

ITALIC SWASH CAPITALS

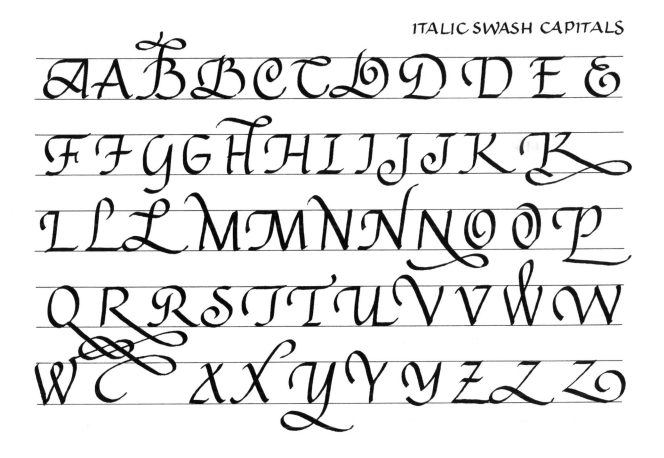

ITALIC SWASH SMALL LETTERS

## SWASH DESIGN

It's easy to write swashes on Italic letters that wow the reader. The problem is to stop! and not overdo it. Each additional swash increases the risk of cluttering the page, and dilutes the visual strength of the swashes that are already there. So, be cautious and choosy when you include swashes in your design.

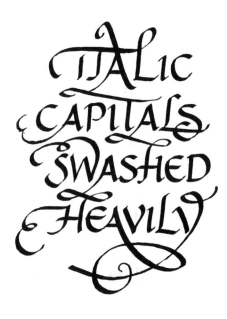

In the beginning you may be tempted to put swashes in many ingenious places. Swashes sometimes seem to yearn to connect two extenders or fill out the line——. It's fun at first to indulge their playfulness.

After the novelty wears off, you should exercise restraint. Swashes look better at the top and bottom of a text rather than inside it, and in pairs or threes that balance each other's visual motion.

As you can see from the comparisons here, swashes on a page are like jewels on a person; it is better to have a big gem carefully placed than a lot of little ones dotted around.

## DESIGNING WITH ITALIC CAPITALS

unswashed or swashed, the Italic capital appears in a wide range of sizes, shapes, and surroundings. It weaves a monogram, shapes a logo, dresses up a word; it capitalizes the Italic small letters as a team member or a star; it italicizes a passage within a text of vertical letters; it blends with other Italic capitals to render short quotations.

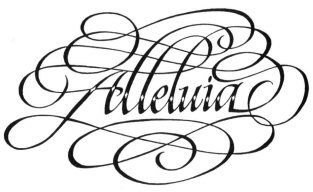

Above: Robert Boyajian

At right and below: Tom Costello

Cyclone logo,
Ames Senior High School.

**SWASH**

*swash*

**Swash**

*swash*

**SWASH EVERY SCRIPT**
*The swash is a scarf that you can add to any outfit, not just to the Italic little black dress. Try on a swash with every alphabet in this book, draping it differently to harmonize with each calligraphic style. Formal Roman swashes bend just slightly near the end. Celtic swashes tie into decorative knots. Gothic swashes look frozen into stiffly starched angles. Bookhand swashes curve and float but don't flutter.*

Michelle Hlubinka

**BEYOND ALPHABET SWASHES**
*You can also give your alphabets an exotic touch with swashes from a foreign script...*

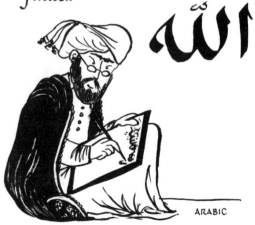

ARABIC

*... or simply borrow whole costumes, as the alphabet did with Arabic numerals.*

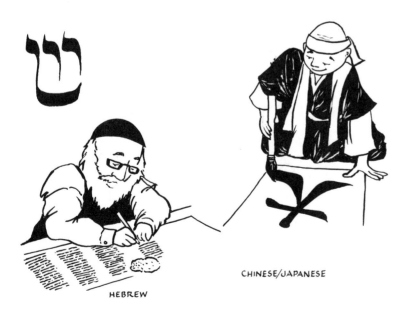

HEBREW

CHINESE/JAPANESE

# NUMERALS & PUNCTUATION

Beginning with the Crusades & growing for 500 years, the powerful new religious force of Islam changed the visual art of Europe. Scribes were confronted with different new ways to count, write, decorate, and punctuate. Numerals and a zero from Sanscrit replaced Roman I, V, and X. Paper from Samarkand supplanted parchment. Swashes from Arabic script softened the angles of Gothic.

Scribes also continued tailoring their own scripts to the realities of everyday copying. Many common words, already shortened down to 2 letters, were further stylized into symbols like & and ℞. Dozens of little marks indicating pauses, abbreviations, & special phrasing have been standardized into today's punctuation marks.

## NUMERALS

Most numerals accompany letters, changing pen weight, height, and angle to match. Numerals come in two versions, capital or small. The forms are nearly identical, differing mainly in their placement between the guidelines. Basic numerals are half as wide as their height. Their top and bottom halves are just slightly unequal.

"CAPITAL" NUMERALS

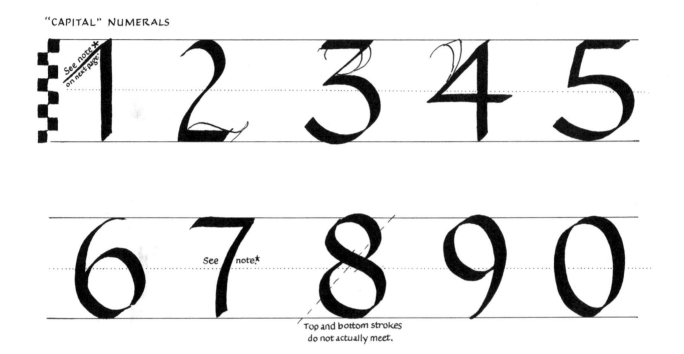

See note* on next page.

See note*

Top and bottom strokes do not actually meet.

One of the virtues of the original Arabic numerals was the individuality of each one, so that no character could be misread for another, even reversed or upside~down. European typographers, however, surpressed the uniqueness of each character in order to make them all look like they belonged with each other. You can emphasize the numerals and parts and strokes that resemble each other to make them work as a team without completely obliterating the individuality that makes them legible.

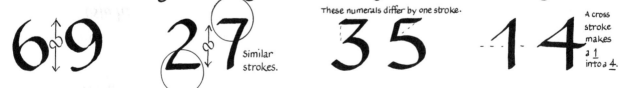

Similar strokes.

These numerals differ by one stroke.

A cross stroke makes a 1 into a 4.

Numerals that accompany small letters extend, like them, beyond the guidelines with ascenders and descenders of similar height. As a general rule, and except for *1* and *0*, the <u>even numbers go up</u> and the <u>odd numbers go down</u>.

"EXTENDER" NUMERALS

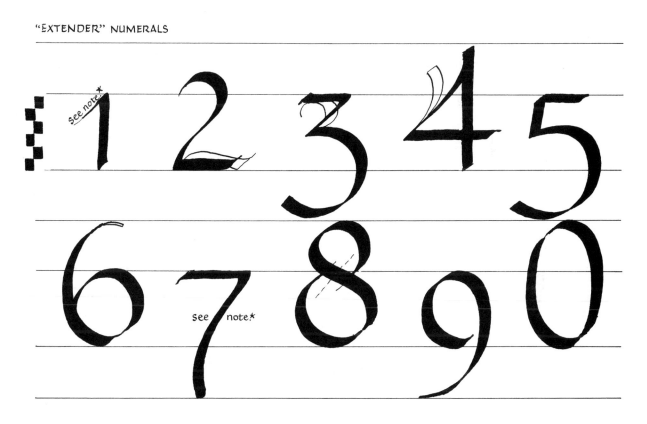

\* Note that the custom of crossing the *7* has been garbled in transmission from Europe to America. This cross stroke serves to distinguish *7* from *1*, which resemble each other only if you write *1* as they do over there, with a strong upstroke. If you don't make the strong upstroke on *1*, you don't need the cross stroke on *7*.

American  1 7        European  1 7

If confusion is likely... use this:

5 3 3

You may also prefer an alternate *3* to prevent the misreading of similarly written figures *3* and *5*.

## PUNCTUATION

Punctuation marks, like numerals, can modify their height, weight, pen angle, and slant to harmonize with the alphabets they punctuate. The basic forms are shown for you to adapt to each alphabet you learn.

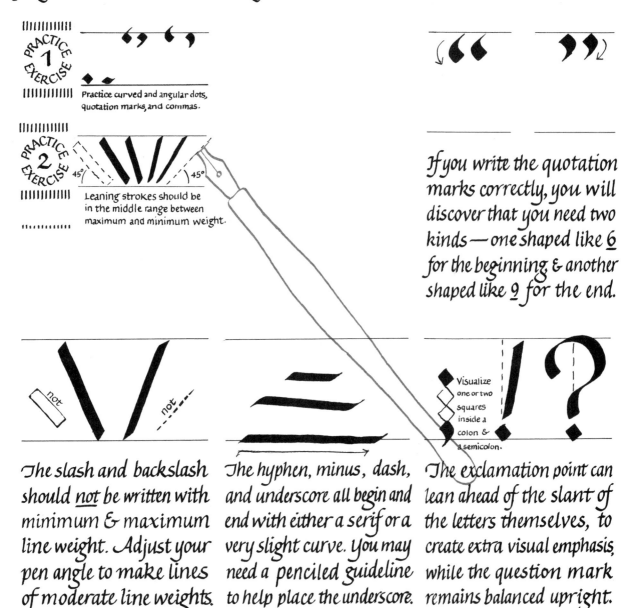

PRACTICE EXERCISE 1

Practice curved and angular dots, quotation marks, and commas.

PRACTICE EXERCISE 2

45°      45°

Leaning strokes should be in the middle range between maximum and minimum weight.

If you write the quotation marks correctly, you will discover that you need two kinds — one shaped like <u>6</u> for the beginning & another shaped like <u>9</u> for the end.

not       not

Visualize one or two squares inside a colon & a semicolon.

The slash and backslash should <u>not</u> be written with minimum & maximum line weight. Adjust your pen angle to make lines of moderate line weights.

The hyphen, minus, dash, and underscore all begin and end with either a serif or a very slight curve. You may need a penciled guideline to help place the underscore.

The exclamation point can lean ahead of the slant of the letters themselves, to create extra visual emphasis, while the question mark remains balanced upright.

Check the author's text to make sure you have not added or omitted punctuation.

## LIGATURES & SYMBOLS

Many familiar characters that supplement the alphabet are assembled from 2 or 3 letters. The LEGO® blocks of the calligrapher's toy chest, ligatures appear as decorative joins, mathematical and musical notations, abbreviations, archaic symbols, borrowed emblems, and invented devices:

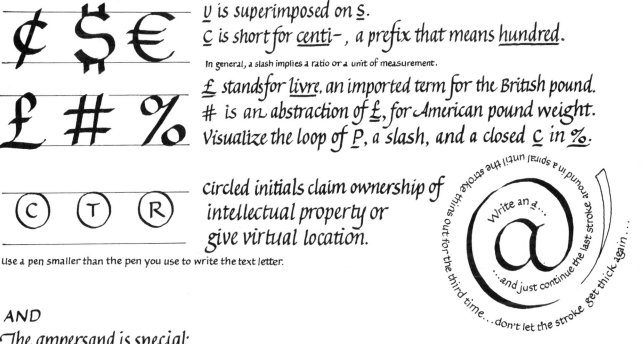

_v_ is superimposed on _s_.

_c_ is short for _centi-_, a prefix that means _hundred_.

In general, a slash implies a ratio or a unit of measurement.

£ stands for _livre_, an imported term for the British pound.
# is an abstraction of _£_, for American pound weight.
Visualize the loop of _P_, a slash, and a closed _c_ in _%_.

circled initials claim ownership of intellectual property or give virtual location.

Use a pen smaller than the pen you use to write the text letter.

## AND

The ampersand is special; it has been accepted as part of a standard alphabet font & yet has no single standard form. It began as medieval scribes merged the letters of _et_, Latin for _and_, into a single character. Now it is written in dozens of forms, from a simple "+" to complex figures that nearly obscure the original _E_ & _T_.

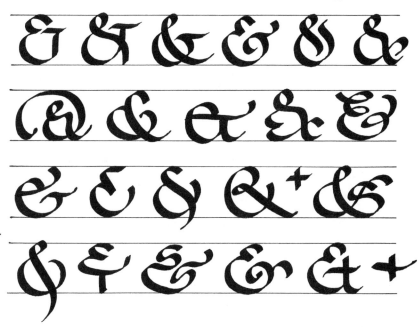

## ROMAN NUMERALS

Add thin lines with a 0° pen angle
or a thinner pen to differentiate

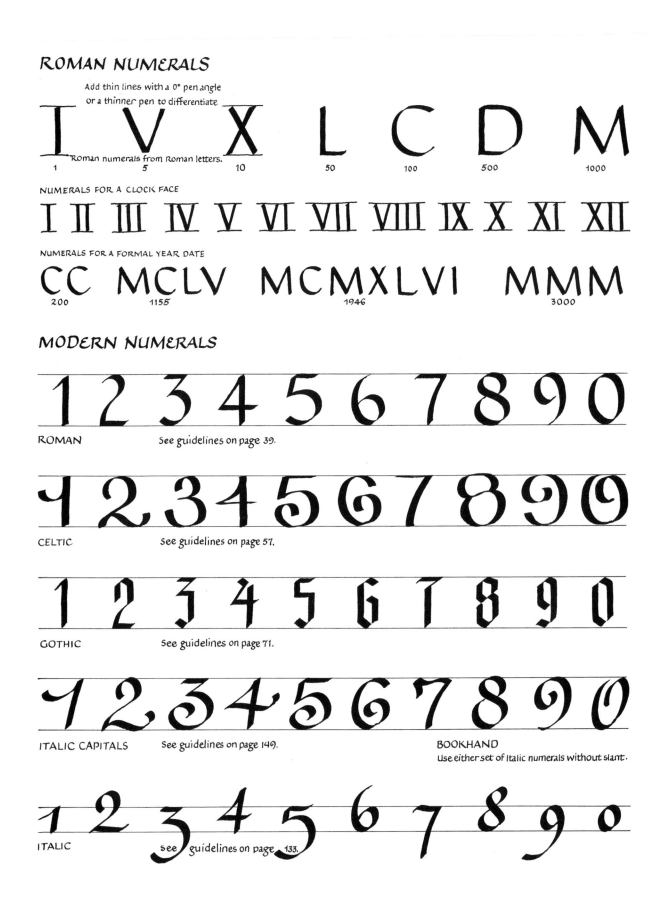

| I | V | X | L | C | D | M |
|---|---|---|---|---|---|---|
Roman numerals from Roman letters.

| 1 | 5 | 10 | 50 | 100 | 500 | 1000 |

NUMERALS FOR A CLOCK FACE

I  II  III  IV  V  VI  VII  VIII  IX  X  XI  XII

NUMERALS FOR A FORMAL YEAR DATE

CC    MCLV    MCMXLVI    MMM

200    1155    1946    3000

## MODERN NUMERALS

1 2 3 4 5 6 7 8 9 0

ROMAN          See guidelines on page 39.

1 2 3 4 5 6 7 8 9 0

CELTIC          See guidelines on page 57.

1 2 3 4 5 6 7 8 9 0

GOTHIC          See guidelines on page 71.

1 2 3 4 5 6 7 8 9 0

ITALIC CAPITALS     See guidelines on page 149.          BOOKHAND
                                                         Use either set of Italic numerals without slant.

1 2 3 4 5 6 7 8 9 0

ITALIC          see guidelines on page 133.

## ZODIAC SIGNS

| ♈ ARIES | ♉ TAURUS | ♊ GEMINI | ♋ CANCER | ♌ LEO | ♍ VIRGO |
|---------|----------|----------|----------|-------|---------|
| THE RAM | THE BULL | THE TWINS | THE CRAB | THE LION | THE VIRGIN |
| March 21-April 19 | April 20-May 20 | May 21-June 21 | June 22-July 22 | July 23-August 22 | August 23-September 22 |

| ♎ LIBRA | ♏ SCORPIO | ♐ SAGITTARIUS | ♑ CAPRICORN | ♒ AQUARIUS | ♓ PISCES |
|---------|-----------|---------------|-------------|------------|----------|
| THE BALANCE | THE SCORPION | THE ARCHER | THE GOAT | THE WATER BEARER | THE FISHES |
| September 23~October 23 | October 24 - November 21 | November 22~ December 21 | December 22~ January 19 | January 20~ February 18 | February 19~March 20 |

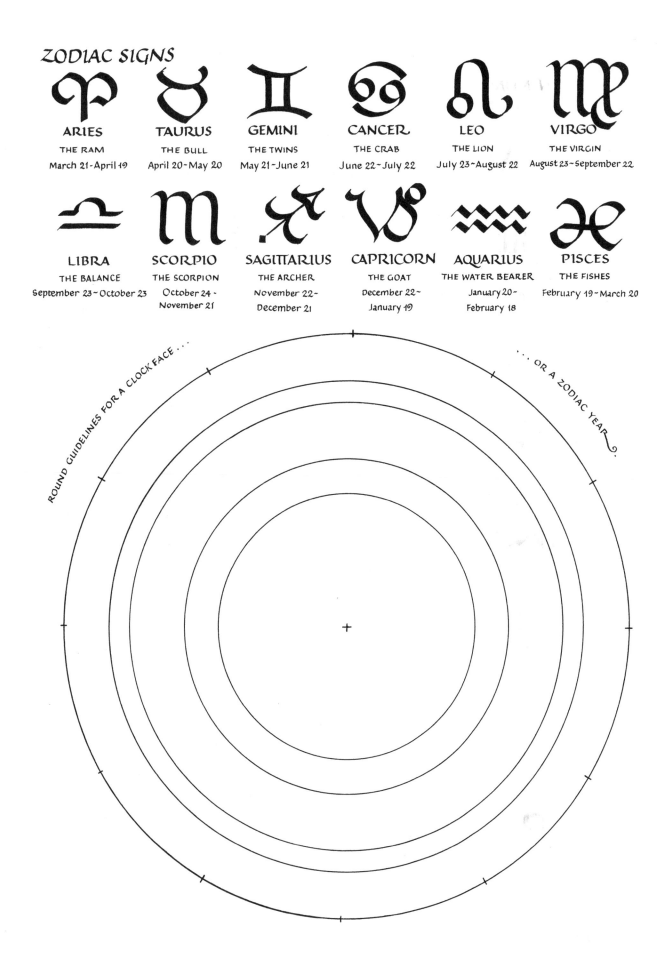

ROUND GUIDELINES FOR A CLOCK FACE . . .

. . . OR A ZODIAC YEAR.

Photo by Jasper Friend

# LEARN CALLIGRAPHY

416
West 20th Street

Robert Boyajian

## NUMERALS IN USE   *Many practical lettering projects require numerals to tell __where__ and __when__.*

Ms. Sylviane Grant & Mr. Andrew Thomas
35 Sheldon Street
Providence, Rhode Island
02906

## LOCATION & DESTINATION
*Numerals identify clearly where something __is__ — a table number on a table or a street number on a house— or where it __is__ __headed__— an address on an envelope.*

*You should choose a letter style for addressing that will be easy for the postal service to read in the size that fits on the envelope. Restrict swashes and unusual alphabets to the person's name & the edges of the envelope to prevent misdelivery and delay. The letter style and ink color should harmonize with the stamp and the paper color.*

Margaret Shepherd and
David Friend and family
267 Clarendon
Boston, MA 02116

July 26, 1788   USA
New York 25

Mr. Mrs. Robert Fitzwilliam
28 Cypress St.
Wellesley Hills · MA 02181

345 East River Drive
Hill City, OK 52145

The U.S. Postal Service
prefers the return
address here . . .

. . . but this location keeps
the front of the envelope
uncluttered.

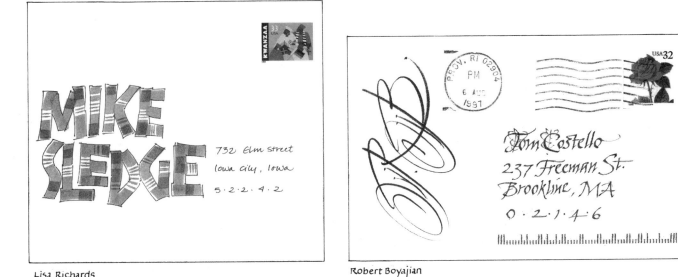

732 Elm Street
Iowa City, Iowa
5·2·2·4·2

Lisa Richards

Tom Costello
237 Freeman St.
Brookline, MA
0·2·1·4·6

Robert Boyajian

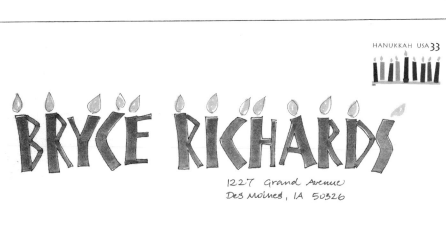

1227 Grand Avenue
Des Moines, IA 50326

Lisa Richards

Whether your envelope holds a party invitation, a holiday greeting, a birthday check, or a love note, you can choose an alphabet style and numerals that reinforce your message. Calligraphy can express your personality on whatever you send in the mail.

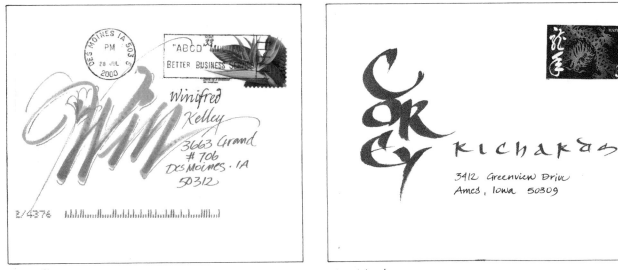

Winifred
Kelley
3663 Grand
#706
Des Moines · IA
50312

Jean Wilson

RICHARDS
3412 Greenview Drive
Ames, Iowa 50309

Lisa Richards

## ENVELOPE TEMPLATES

Addressing envelopes is good practice. Guidelines let you concentrate on the letters:

1. Copy ★ these guides onto transparent material and insert in envelope. Light it from the back to let the lines show through.

2. Or copy ★ these guides onto heavy paper and cut away slots for pencil lines. After the letters have dried, erase the lines (page 21).

★ No copier? Cut these from the page & use.

Extra M's are given here, to vary the titles that start with M: Mr., Mrs., Miss, Ms.

ONLINE GUIDELINES www.margaretshepherd.com

abcdefghijklmnopqrstuvwxyz 1234567890

## TIME PAST AND TO BE

Numerals describe when an event already happened —a monument or plaque— or when it will happen— a poster or invitation.

Gordon and Grethe Shepherd request the pleasure of your company at the marriage of their daughter *Lisbeth Francisca* to *Kevin James Delaney* son of James and Sylvia Delaney

at Humlum Parish Church Denmark on Saturday, 1 August 1998 at 4:00 o'clock P.M.

and for dinner afterwards at Nørre Vosborg Black tie optional

Times and dates usually have a mix of numerals & letters. Although you should consult an etiquette book for a wedding or a formal party, you can use a general rule: words look more formal than digits. To add visual formality, you can spell out numerals as words, and just include more words, period. Use "Saturday, March fourteen" rather than "March 14", and "Five-thirty in the afternoon" rather than the more casual "5:30 P.M."

Robert Boyajian

## SPECIAL NUMERALS

Some anniversaries and birthdays carry a special symbolism. your pen can transform them into emblems that crystallize a moment.

Third BIRTHDAY!

Celebrating Our 25th. Anniversary Society of Scribes Ltd.

ENOUGH! FAREWELL, KIND READER,

# TANTUM!
<sub>1775</sub>

AND EMBRACE ME AND ALL

# LECTOR
<sup>CALLIGRAPHICA</sup>

CHAMPIONS OF CALLIGRAPHY

# BENEVOLE
<sup>SCHWANDER</sup>

IN YOUR PERENNIAL FAVOR.

## THIS BOOK WAS HANDLETTERED BY THE AUTHOR

on Strathmore Calligraphy Document paper, one and one half
times larger than final size, in standard Italic style
except for the eccentric g, in a 4 mm letter
body spaced on 1 cm, using a 1 mm
Brause nib dipped in India Ink.
White-out covered up
all mistakes or
just about
all

10
9
8
7
6
5
4
3
2
1
Zero

BLAST OFF!